Photoshop Tutorials ::

33 PROFESSIONAL PHOTOSHOP TUTORIALS
For The Price Of A Camera Strap

$10 OFF - LIMITED TIME OFFER - JOIN AT THE BOTTOM OF THE PAGE!

HOW TO CREATE A CARTOON CHARACTER WITH PHOTOMANIPULATION & RETOUCHING

Photoshop Tutorials ::

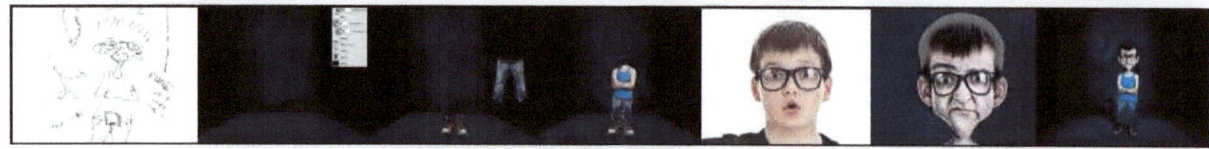

TRANSFORMING PHOTOS OF REAL PEOPLE INTO CARICATURES

Photomanipulation + Retouching + Color Grading Tutorial

We will be covering a lot of things in this massive tutorial. You will learn step by step how you can create any cartoon character you imagine using photomanipulation, retouching and color grading techniques. With only **Photoshop** and stock photos (or your own) you can create a unique caricature that can be a logo, a mascot for a product, a character in an ad, etc.. You can of course use the same techniques explained in this tutorial, in a more subtle way, to spice up your portraits or images.

This tutorial has a massive 89 steps detailing the entire process to achieve the image above and don't

Photoshop Tutorials ::

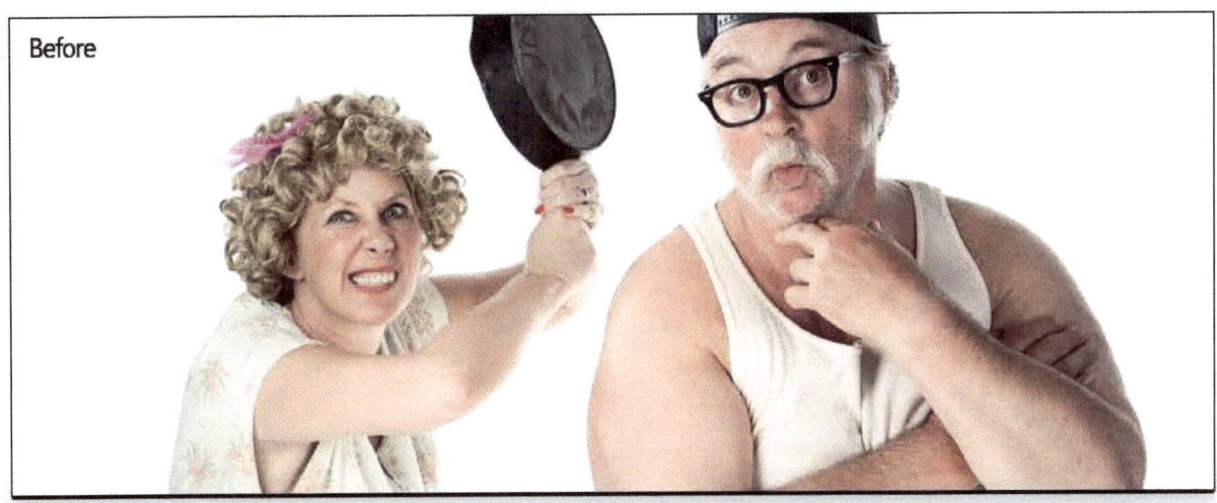

USING PHOTOSHOP TOOLS TO ADD DEPTH & CHARACTER TO A FACE

Advanced Retouching Tutorial

In this **130-minute video tutorial** I will show you different retouching techniques and tricks that will help you transform regular people into eye-popping characters. In this Photoshop tutorial, we will enhance the facial features of the man and the woman giving them a funny cartoonish look perfect for our artwork. We will then work on colors and add a background that will mesh well with our characters. In this case, I choose a background that would give the impression that those two were in an insane asylum!

(Subtitulos En Español: Sí)

Click Here For More Details About This Tutorial + Bigger Images

JOIN NOW TO GET ACCESS TO ALL TUTORIALS!

HOW TO MAKE YOUR PORTRAITS LOOK OUT OF THIS WORLD

Photoshop Tutorials ::

worry, all my tutorials can be done by anyone who has basic knowledge of Photoshop. Unlike other tutorials you'll sometimes see out there, you don't need to be a skilled digital painter to achieve the same results I get here - as I'm not a good digital painter myself ;)

(Traducción En Español: Aún No)

Click Here For More Details About This Tutorial + Bigger Images

HOW TO MAKE FACIAL FEATURES POP OUT WITH RETOUCHING

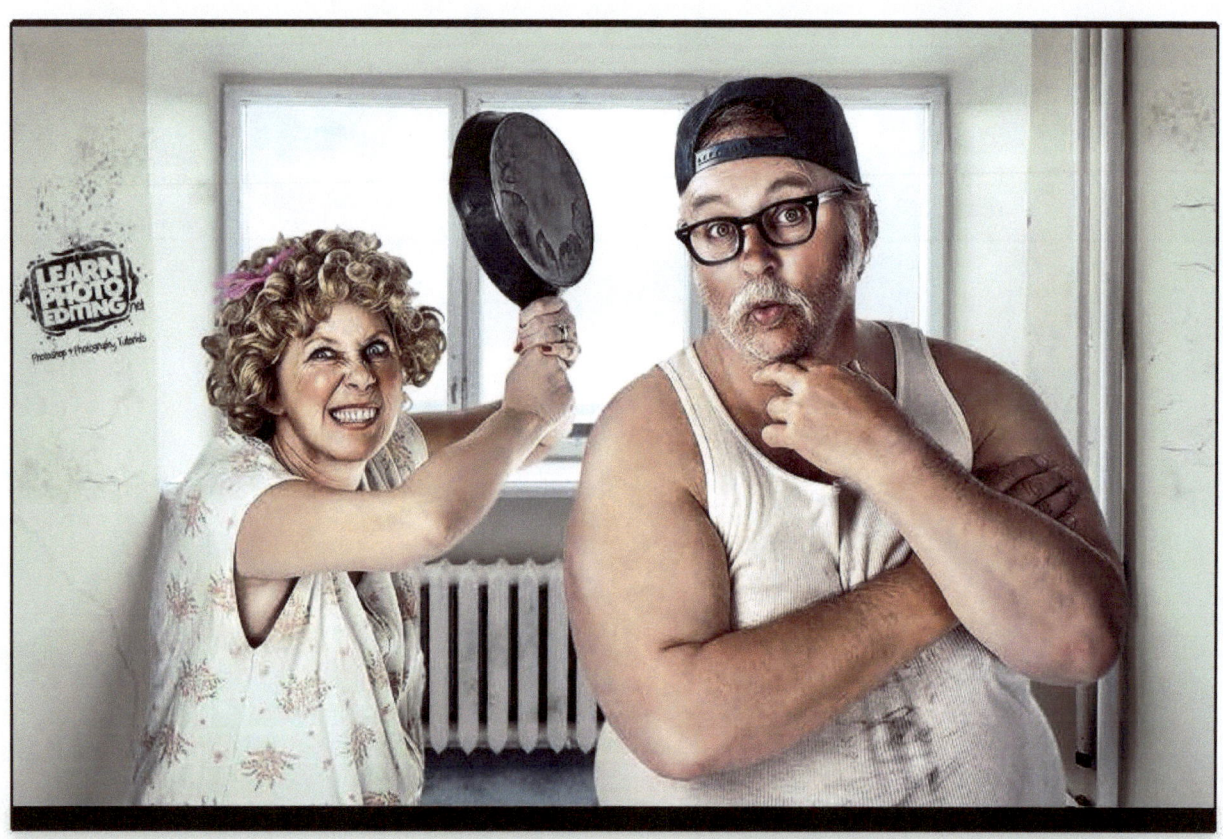

Photoshop Tutorials ::

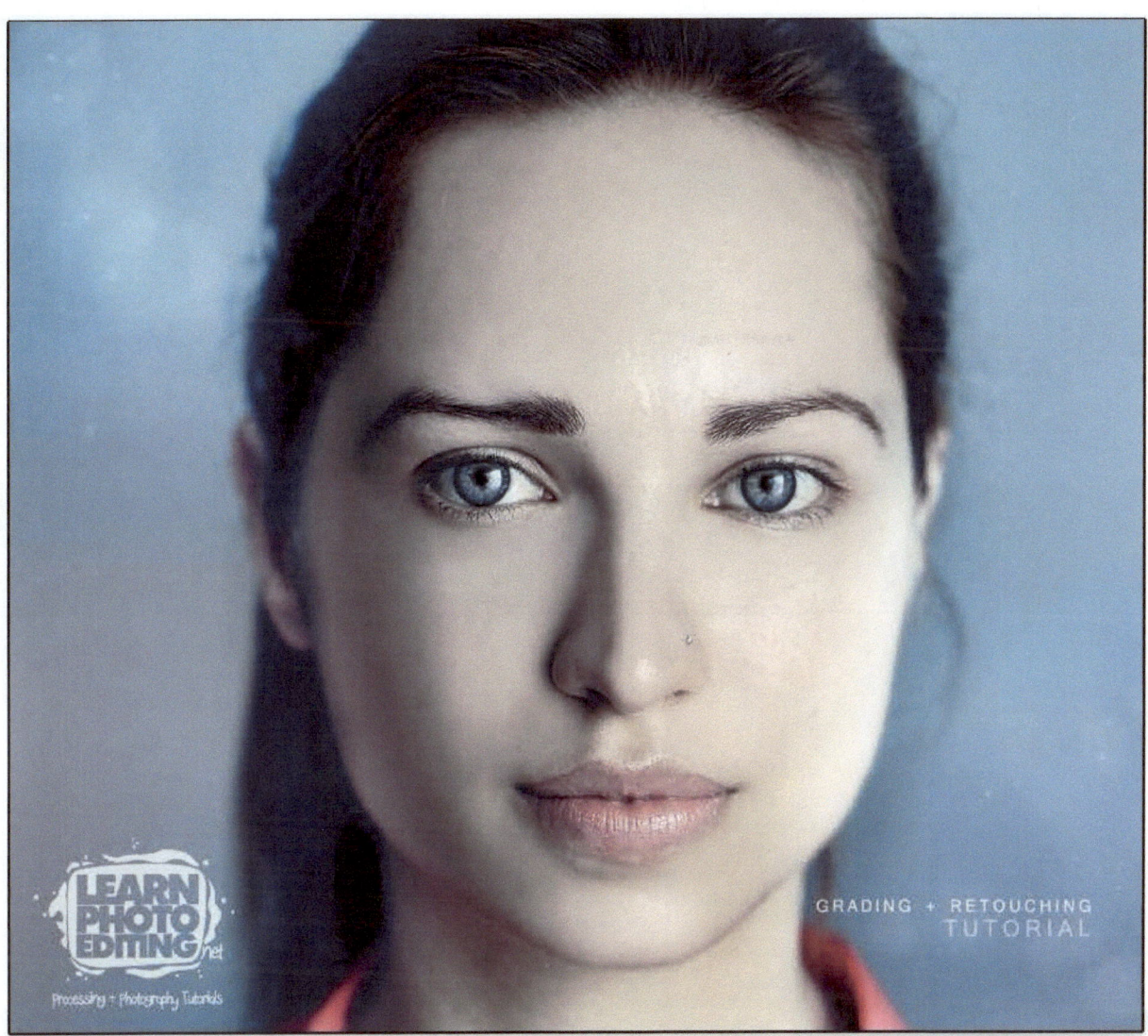

Photoshop Tutorials ::

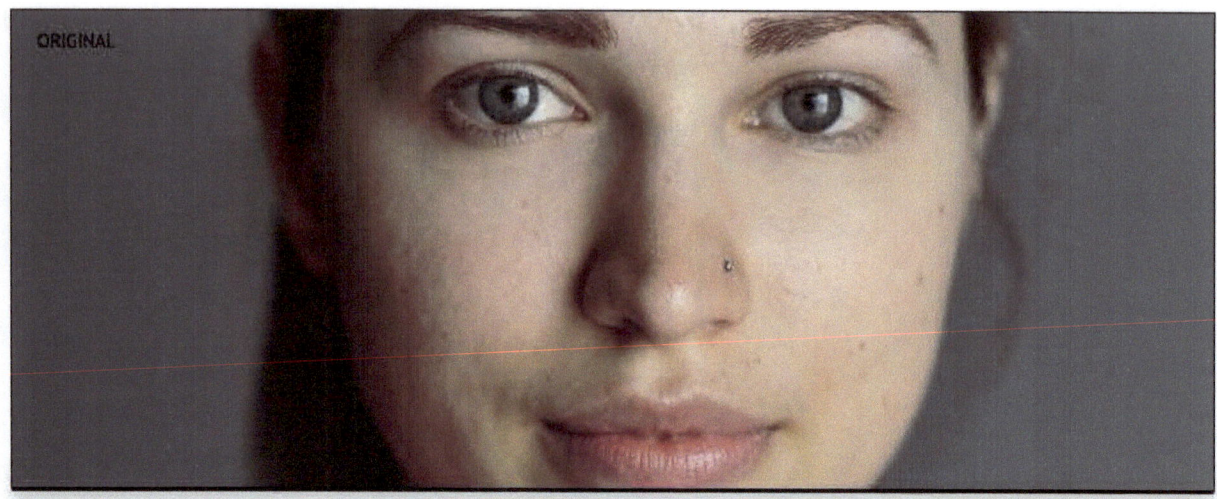

USING RETOUCHING TECHNIQUES TO CREATE FANTASY PORTRAIT

Retouching + Color Grading

In this **50 minute VIDEO tutorial**, we will start with an unretouched portrait of a girl, a photo anyone can take at home with their camera and transform it into some sort of fantasy character. We will go through every step I took to get the final result, from working on the skin, color grading, lighting and finishing with the background.

With the techniques you'll master after completing this **Photoshop tutorial**, you will be able to create many different looks for your portraits, whether you just want a subtle enhancement or you really want to push it and transform your portrait into something that is out of this world!

(Subtitulos En Español: Sí)

Click Here For More Details About This Tutorial + Bigger Images

HOW TO CHANGE THE LIGHTING IN A PHOTO

Photoshop Tutorials ::

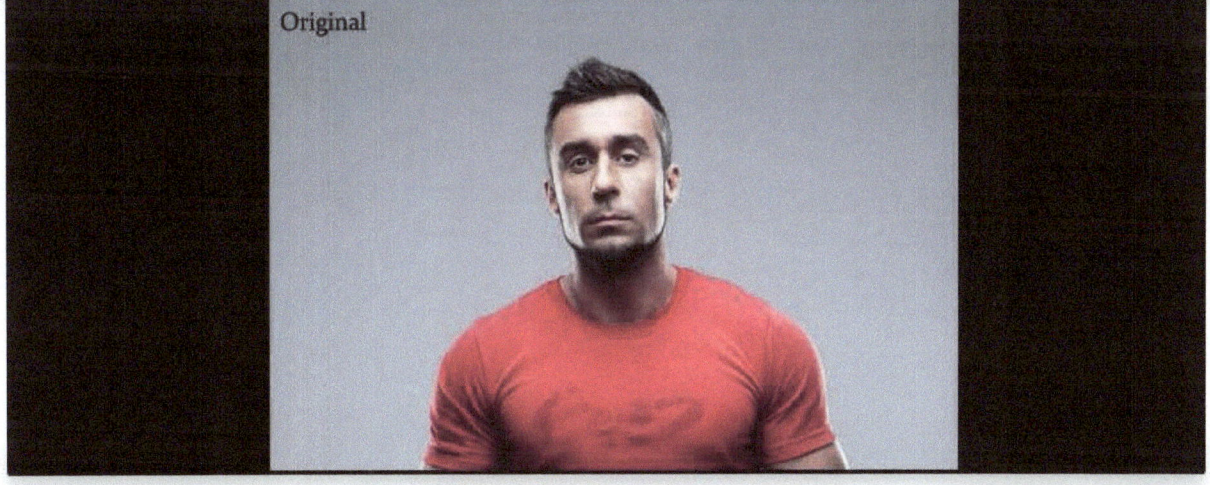

ADDING SPECIAL EFFECTS TO MAKE YOUR IMAGE STAND OUT

Retouching + Color Grading

Photoshop Tutorials ::

In this **140-minute VIDEO tutorial**, we will start with a basic studio photo and create a completely different, much darker environment, add sources of lights and create a cool smoky vapor effect which will give our photo the look of a commerical poster featuring a celebrity athlete.

By mastering the Photoshop techniques shown in this tutorial, you will be able to create any mood you wish for your photos even though they were taken in a bright environment! You will also learn how to create light effects that will make your photos "pop" and grabs everyone's attention!

(Subtitulos En Español: Sí)

Click Here For More Details About This Tutorial + Bigger Images

HOW TO GLAM UP A BUDGET PHOTO SHOOT WITH EDITING

Photoshop Tutorials ::

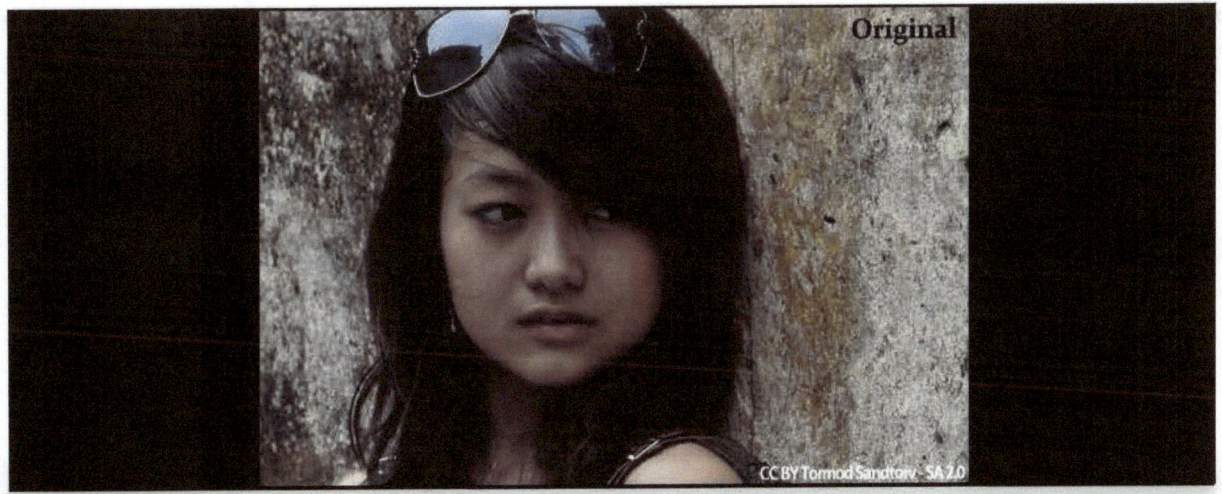

USING GRADIENTS TO TRANSFORM THE LOOK AND MOOD OF A PHOTO

Retouching + Color Grading

In this **150-minute VIDEO tutorial**, we will use gradients to glam up a casual portrait and make our subject look like a high-end fashion model! After using a very effective retouching technique to create our base, we will then create a totally different look and mood by using a variety of gradients along with other color grading techniques.

Gradients are very powerfull when you understand how to use them. If you are serious about photo editing, you must add this important tool to your toolbox!

(Subtitulos En Español: Sí)

<u>Click Here For More Details About This Tutorial + Bigger Images</u>

HOW TO CREATE A SURREAL LOOKING CHARACTER WITH ADVANCED RETOUCHING TECHNIQUES

Photoshop Tutorials ::

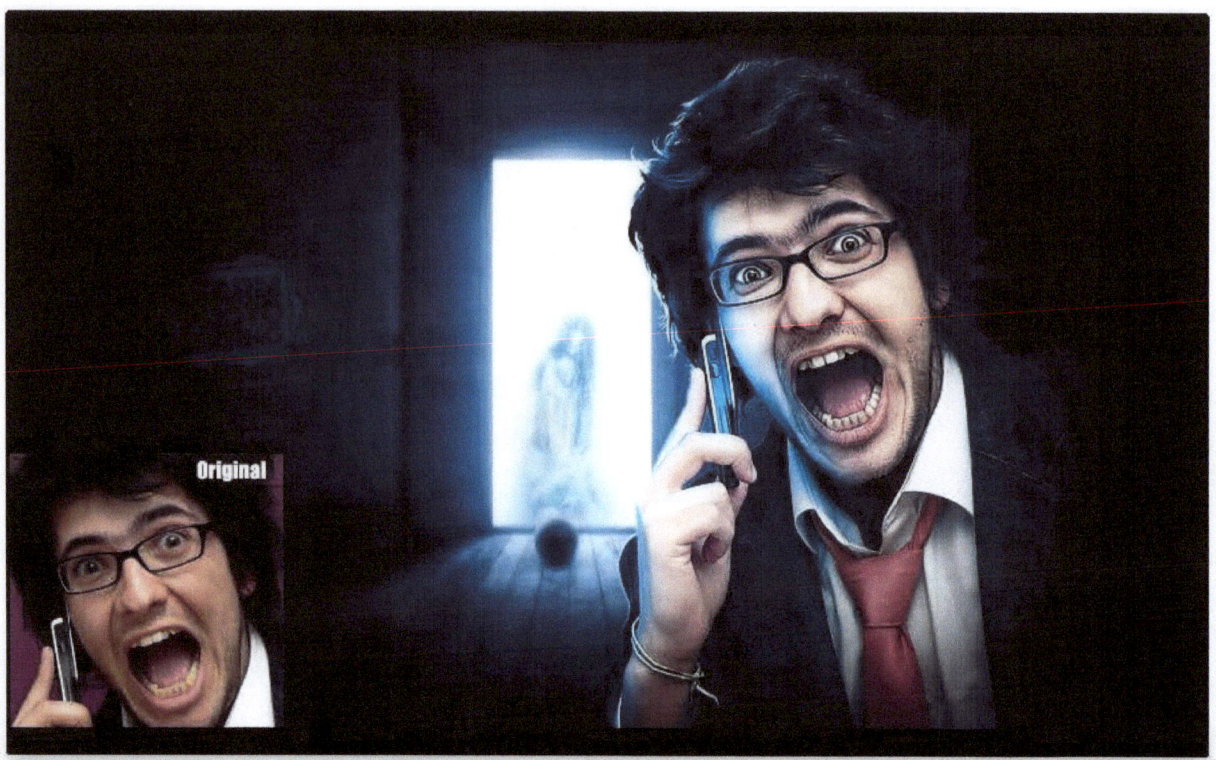

TRANSFORMING AN AVERAGE JOE INTO AN EYE POPPING CHARACTER

Retouching + Photomanipulation + Color Grading Tutorial

In this detailed **3-hour Video Tutorial**, I will show you step by step how you can turn an average Joe into a surreal eye-popping character using advanced retouching techniques. We will also be working on adding light effects to the image, adding a rim light around our character and then color grading our scene to make it look rather creepy.

This Photoshop tutorial will benefit anyone who wants to take their game to the next level when it comes to creative portrait retouching!

(Subtitulos En Español: Sí)

Click Here For More Details About This Tutorial + Bigger Images

HOW TO TURN YOUR PHOTOS INTO HIGH IMPACT MAGAZINE ADS

Photoshop Tutorials ::

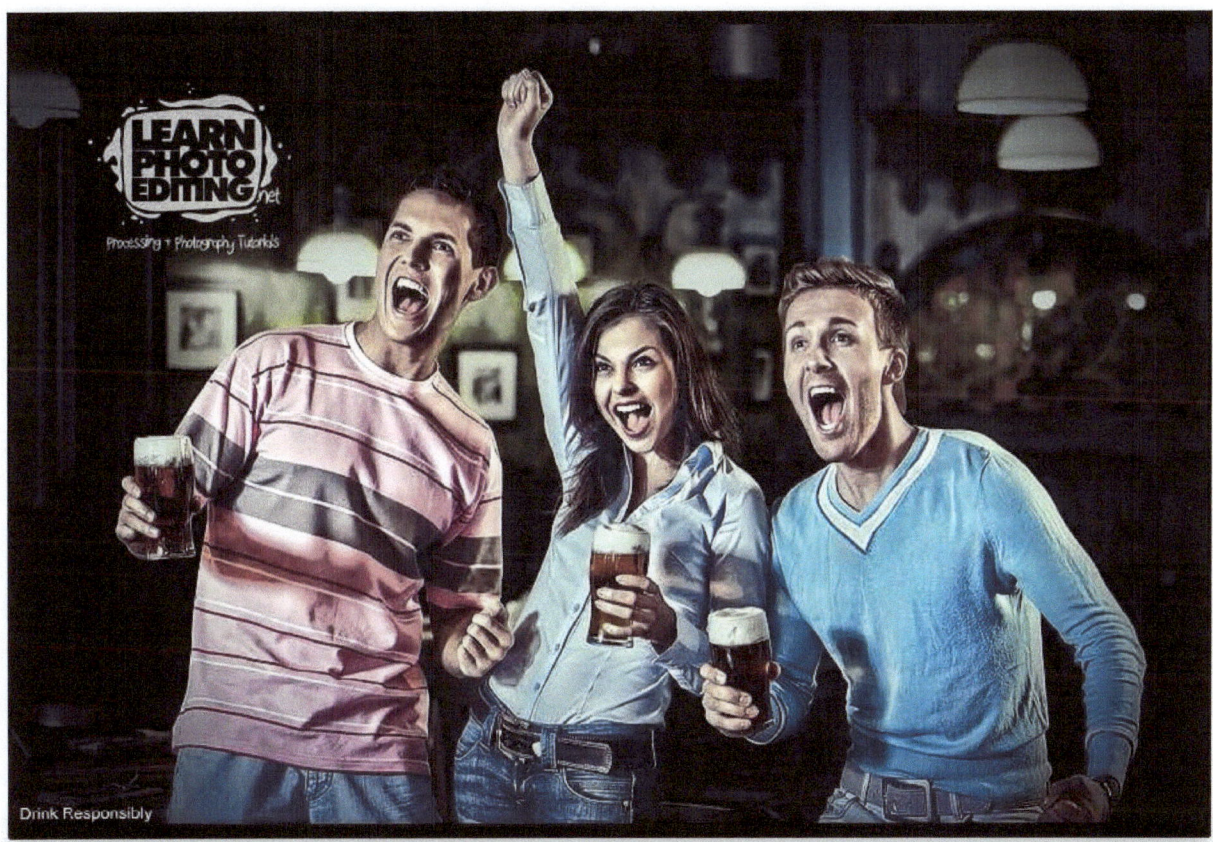

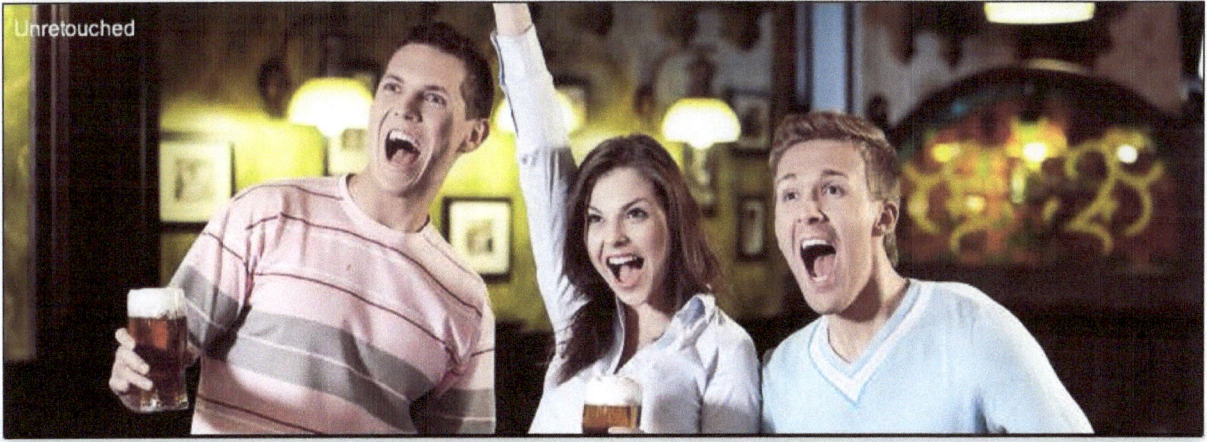

GIVE YOUR PHOTO A "PAINTED LOOK" WITH SURREAL CONTRASTS & COLORS

Advanced Color Grading Tutorial

In this **55-minute video tutorial** we will use advanced color grading techniques to transform a photo that desperately needs more punch into an high impact image that could be used in a magazine ad for example. By using different techniques to exaggerate to contrasts and accentuate the colors, we can give our photo a sort of "painted" look that is very popular right now with commercial photographers. If you

Photoshop Tutorials ::

want to take your photography to another level, this tutorial will show show step by step how to edit your photos like the pros. And if you are a graphic designer, the knowledge you will learn in this Photoshop tutorial will further help you to create eye-popping art!

ALSO, because we dramatically enhances the contrast and details of the photo, this technique becomes perfect for anyone who wants to create stunning **Black & White** photos. **CLICK** the image above or the link below to see how the B&W photo looks like!

(Subtitulos En Español: Sí)

<u>Click Here For More Details About This Tutorial + Bigger Images</u>

HOW TO GIVE YOUR PORTRAITS THE "VIDEO GAME LOOK"

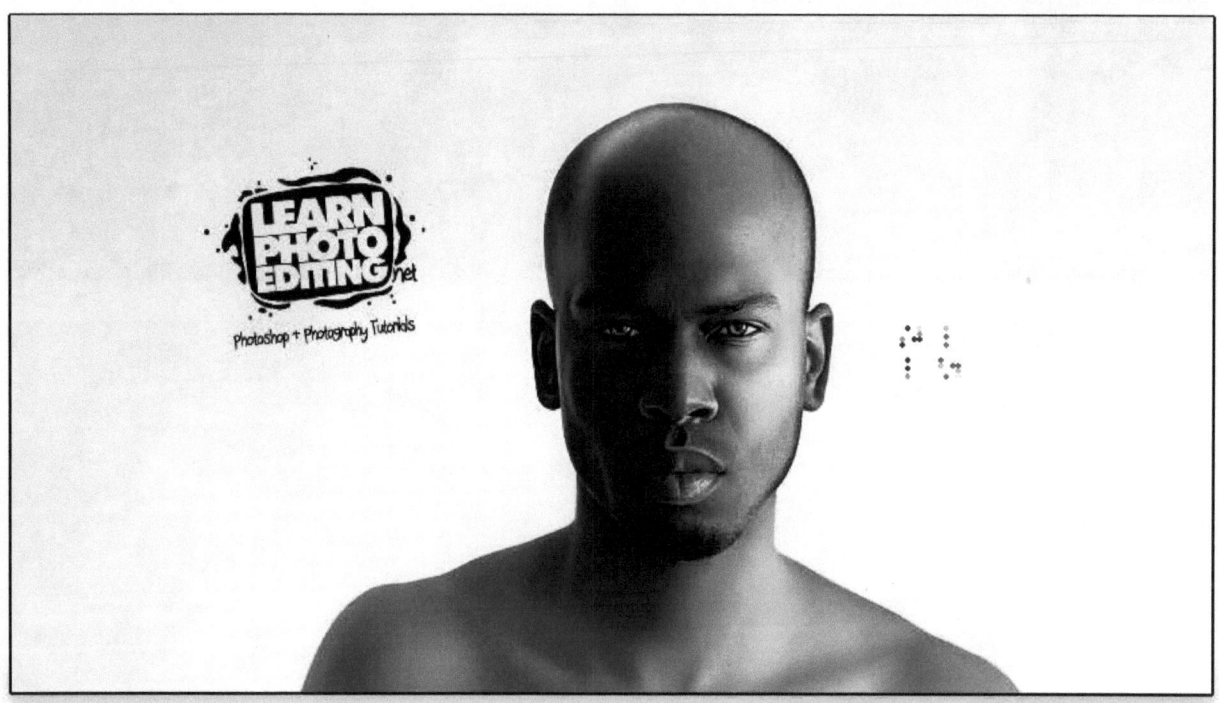

Photoshop Tutorials ::

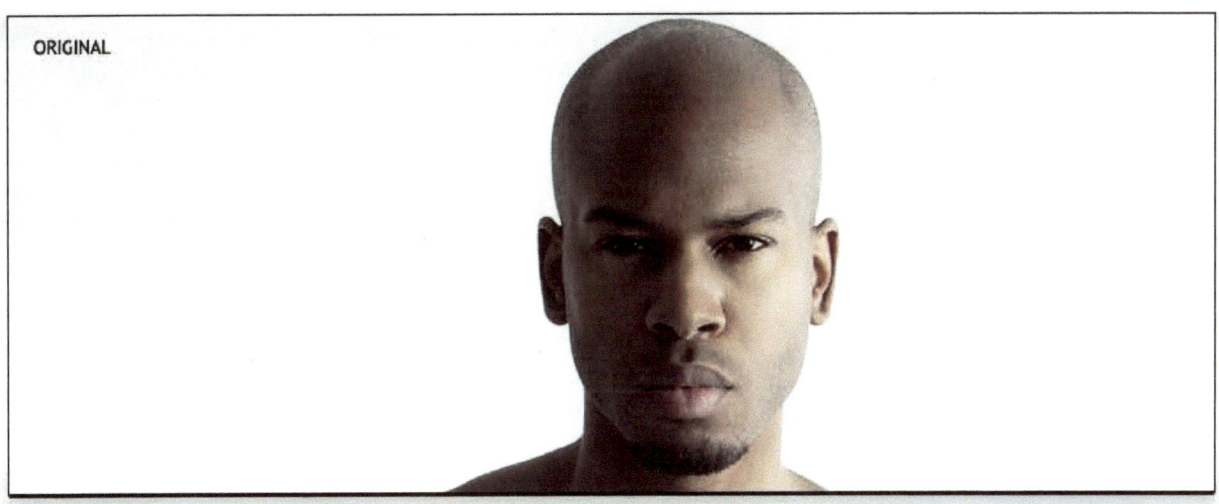

TRANSFORMING A PORTRAIT INTO SOMETHING SLEEK AND ARTISTIC

Retouching Tutorial

Video games these days are more and more realistic and a lot of attention is put on the esthetics of their 3D characters. In this **2 hour+ Video Tutorial**, we will transform a portrait of a regular guy into something that look straight out of the latest video game. And of course, if you want something that looks a little more realistic, we can easily tone down the effects while keeping a very original look!

In this Photoshop tutorial we will use advanced retouching techniques that you can use to create that same sleek/artistic look for any portraits.

(Subtitulos En Español: Sí)

Click Here For More Details About This Tutorial + Bigger Images

JOIN NOW TO GET ACCESS TO ALL TUTORIALS!

HOW TO CREATE MORE IMPACTFUL PORTRAITS

Photoshop Tutorials ::

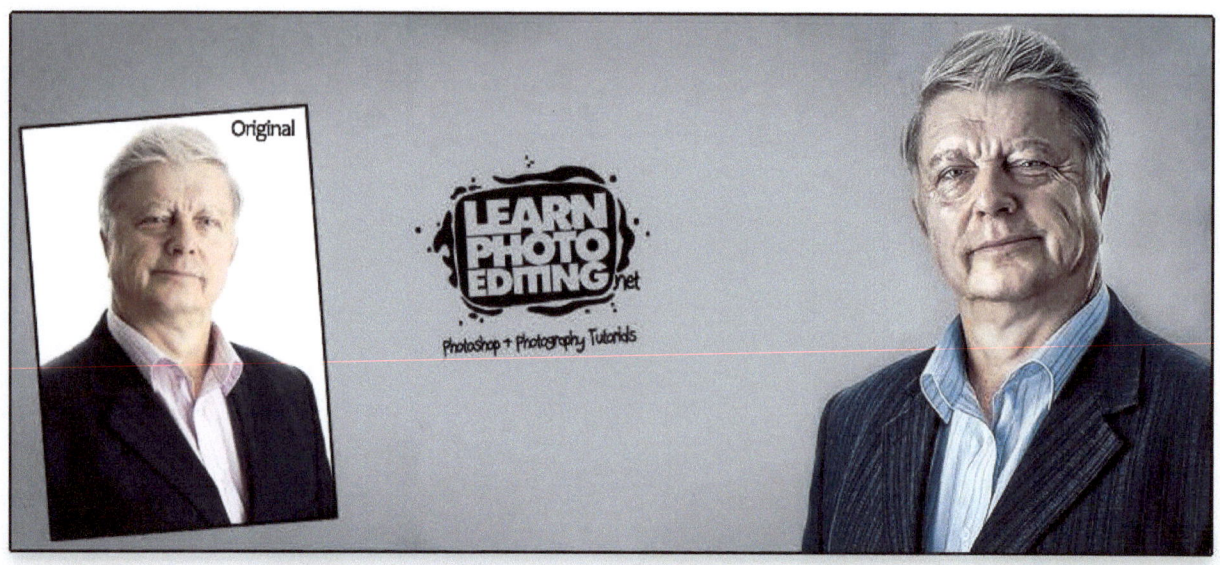

IMPROVING THE LOOK OF THE SKIN WITH STYLE

Color Grading + Retouching Tutorial

In this **105-minute video tutorial**, I show you how you can improve the look and details of someone face/skin and really give your photos or the people in your photomanipulatons a very cool and impactful look! Starting with a generic picture of a business man, we will layer by layer improve the details, contrasts and colors until we get something that will really get people's attention!

(Subtitulos En Español: Sí)

CLICK HERE For More Details About This Tutorial

HOW TO TURN A GIRL INTO A SURREAL CHARACTER

Photoshop Tutorials ::

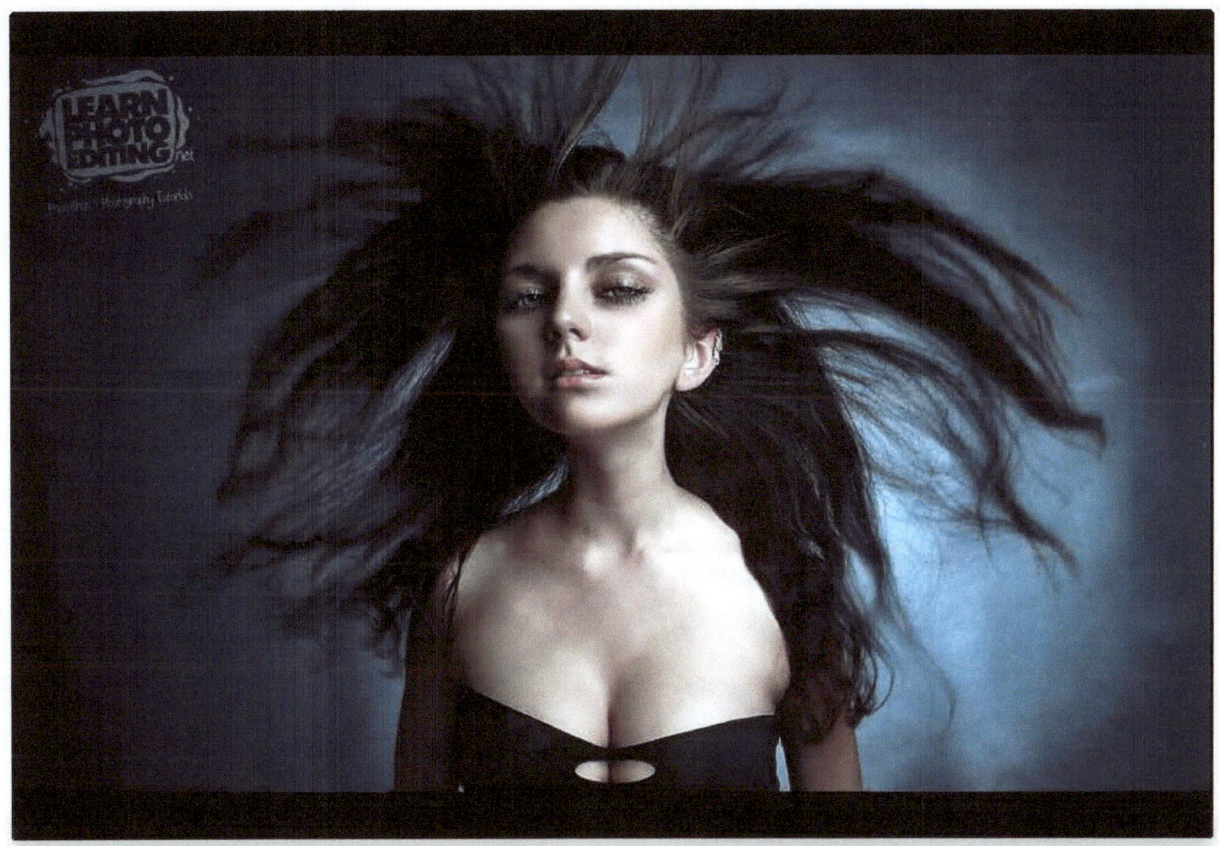

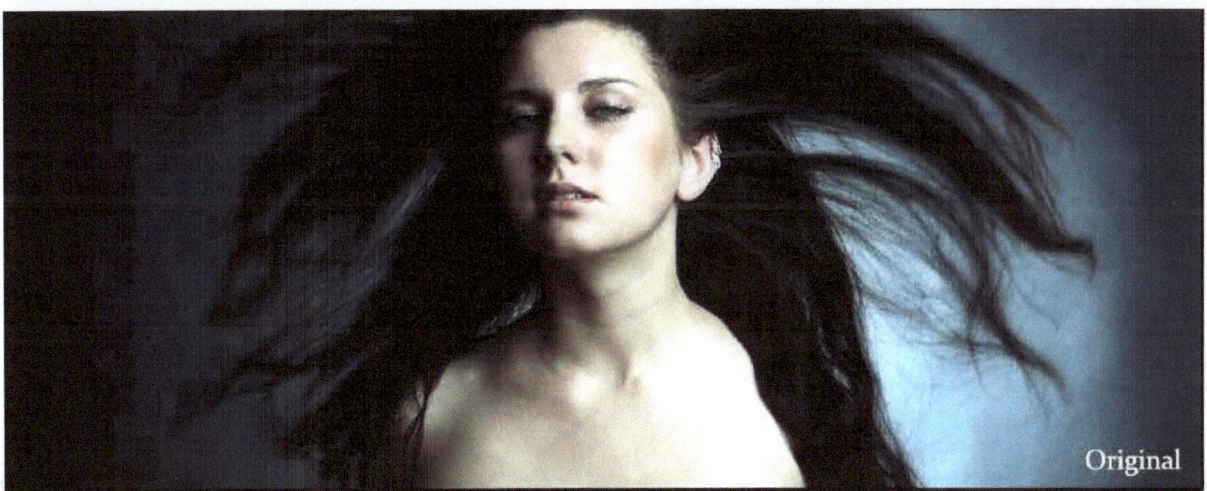

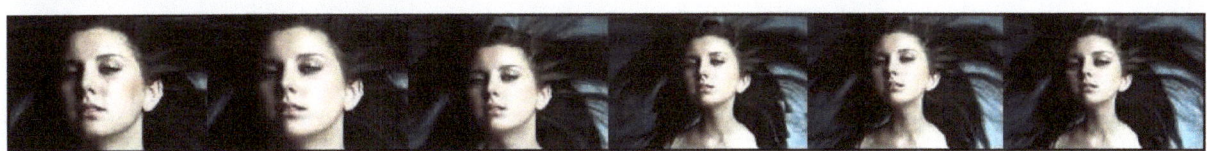

USING RETOUCHING & PHOTOMANIPULATION TECHNIQUES TO CREATE A DISNEY-LOOKING CHARACTER

Advanced Retouching/Photomanipulation Tutorial

In this **87-minute video tutorial** I will show you how to use the photo of a person and transform him or

Photoshop Tutorials ::

her into an eye-popping real-life looking Disney character! We will first use a pretty neat technique to retouch the model, the skin and then we will use photomanipulation methods to transform the girl into someone with pretty wacky proportions which will give us a very cool and surreal result!

In this Photoshop tutorial, we will cover many aspects of photo editing which will surely help you make your photos "pop" and attract attention!

(Subtitulos En Español: Aún No)

Click Here For More Details About This Tutorial + Bigger Images

HOW TO CREATE STYLISED BLACK & WHITE PORTRAITS

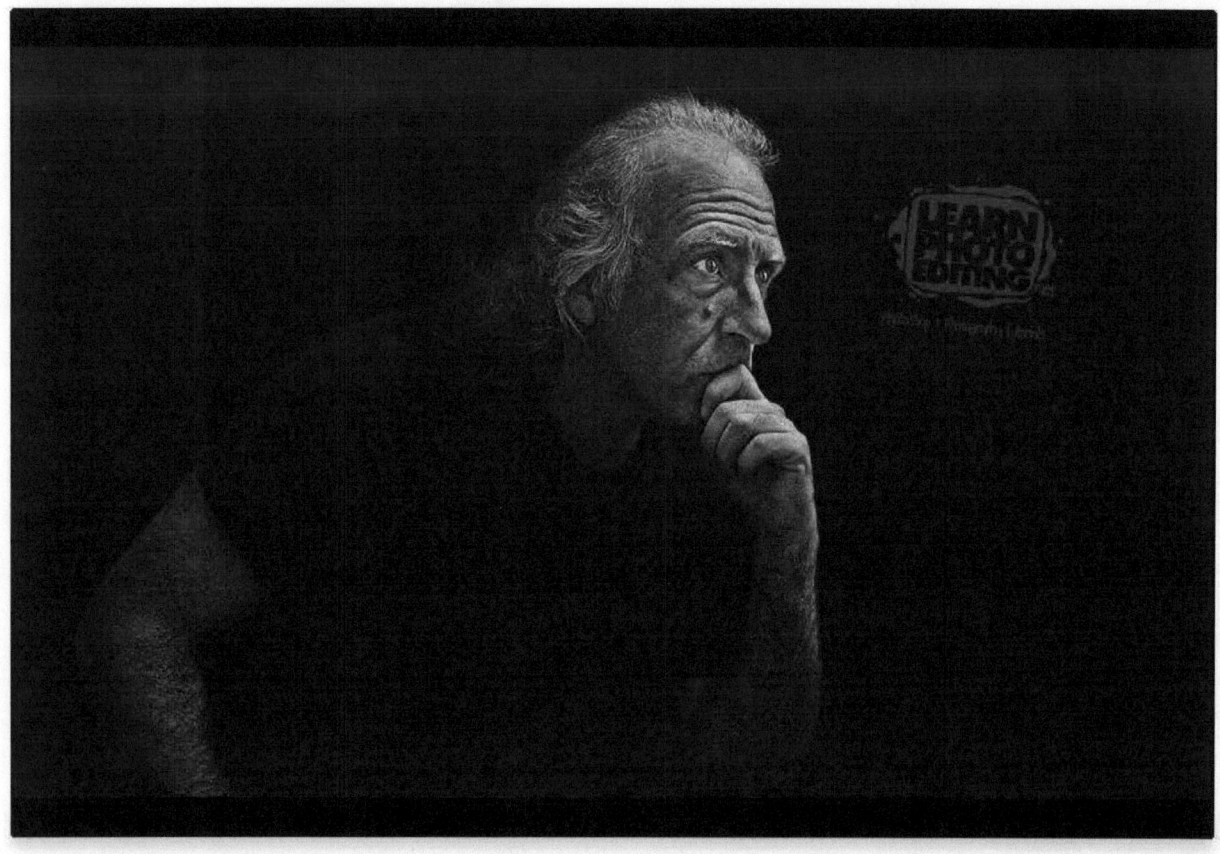

Photoshop Tutorials ::

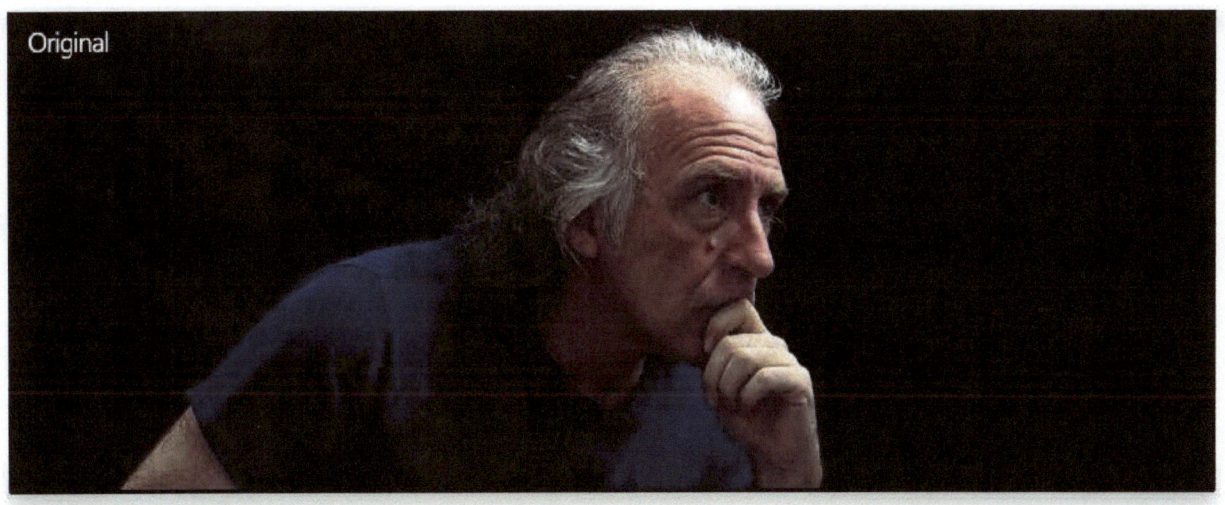

GOING BEYOND BLACK & WHITE

Advanced Photo Editing Tutorial

In this **40-minute video tutorial**, we will create a black & white portrait giving it a style often seen in promotional images of TV series like 'Game of Thrones' and 'Sons of Anarchy'. Simply desaturating your photos to create a black & white image will only give you basic results - and who just wants basic results? If you want to create awesome B&W photos that will stand out from the rest, this tutorial is for you!

(Subtitulos En Español: Sí)

Click Here For More Details About This Tutorial + Bigger Images

JOIN NOW TO GET ACCESS TO ALL TUTORIALS!

HOW TO ADD AN ENCHANTED ATMOSPHERE TO YOUR PHOTOS

Photoshop Tutorials ::

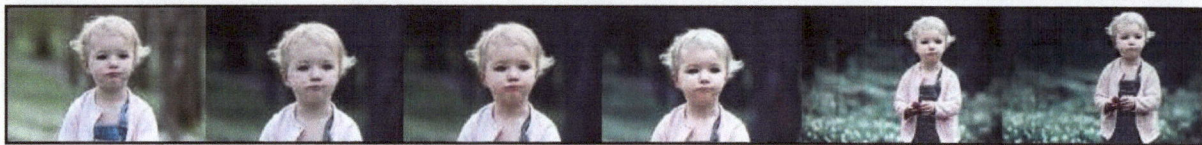

IMPROVING THE BACKGROUND AND MAKING YOUR SUBJECT POP OUT

Advanced Color Correcting Tutorial

In this **2 hour video tutorial** we will take this photo of a little girl standing in the woods, transform it into a fairytale-like scene and make her pop out of the photo! Most of this tutorial will focus on color correction/color grading techniques that will allow you to drastically change the look of a photo!

If you are looking to make your photos 'pop' more by improving the look of the background and foreground, this tutorial is for you!

(Subtitulos En Español: Aún No)

[Click Here For More Details About This Tutorial + Bigger Images](#)

Photoshop Tutorials ::

HOW TO CREATE A FANTASY ENVIRONMENT WITH PHOTOMANIPULATION

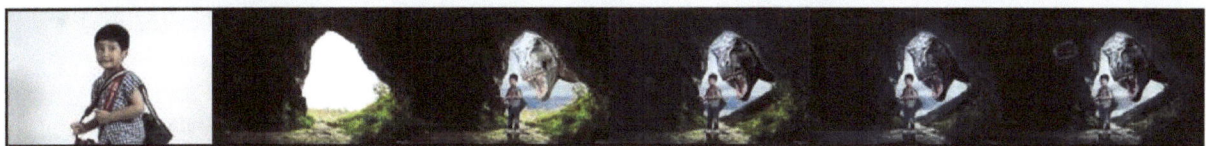

USING PHOTOMANIPULATION AND COLOR GRADING TO ADD CREATIVITY TO YOUR PHOTOS

Color Grading + Photomanipulation Tutorial

If you are a professional photographer, you absolutely need to learn the art of photomanipulation as this simple skill will allow you to offer much more than simple photos to your clients, you could offer them, for example, a trip back in time! Way back!

My friend and great artist **Rivo Rareano** created this tutorial exclusively for the members of

Photoshop Tutorials ::

LearnPhotoEditing.net using a photo he took of his son to create this beautiful "Lost World" art. In a **Video Tutorial** that last just about 2 hours, I will recreate his fantastic image and will explain to you step by step how Rivo created it. The end result is what you see above! In this Photoshop tutorial, you will not only learn about photomanipulation but also different color grading techniques

(Subtitulos En Español: Aún No)

<u>Click Here For More Details About This Tutorial + Bigger Images</u>

HOW TO TURN A DAYTIME SCENE INTO A NIGHT SCENE

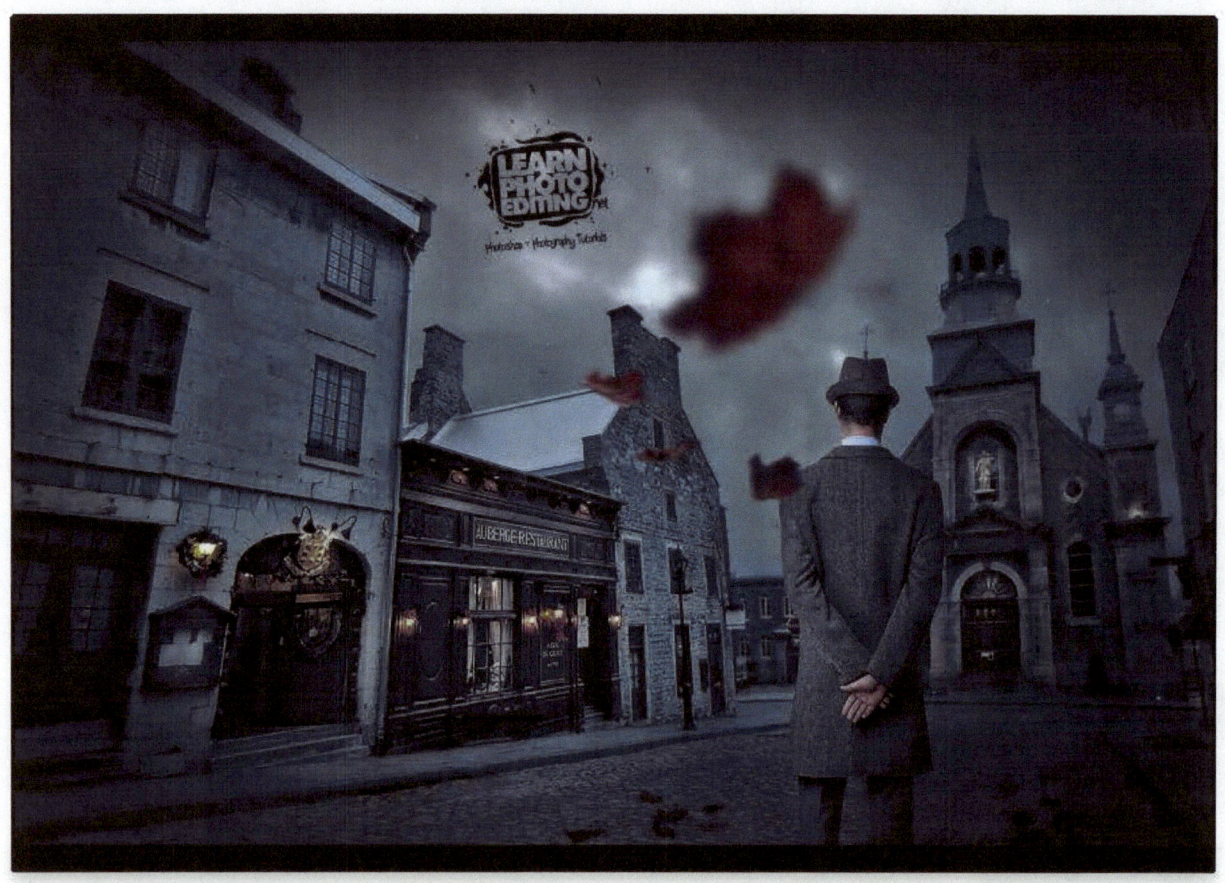

Photoshop Tutorials ::

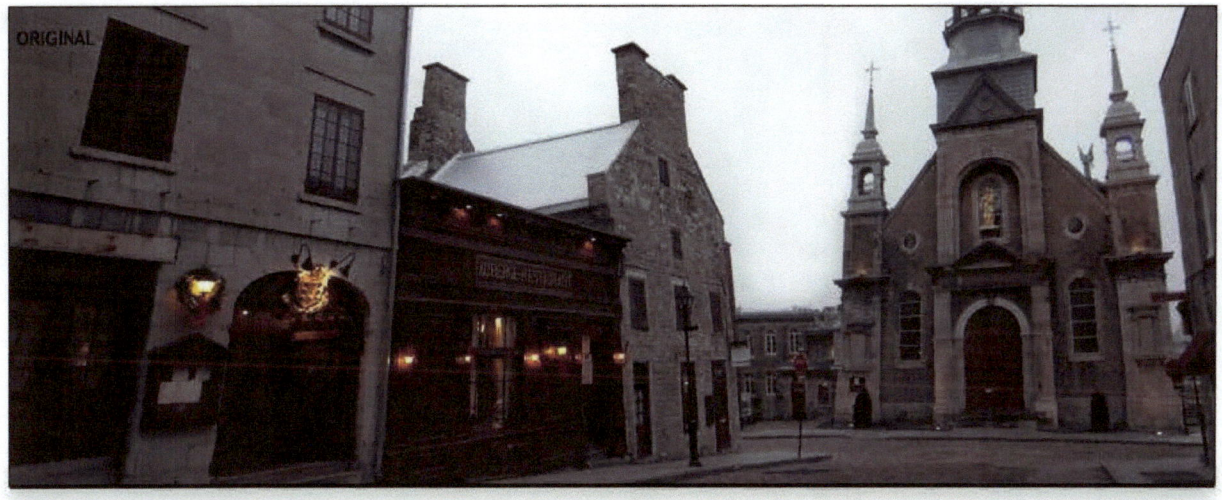

ADDING DETAILS, COLORS, SHADOWS & HIGHLIGHTS TO A CITY SCENE

Photo Editing Tutorial

In this **115-minute Video Tutorial**, we will transform this photo taken in Old Montreal and turn it into a night scene where we will focus on accentuating the details, add elements to spice up the image and work on the highlights and shadows to make everything pop more!

The photo editing techniques learned in this tutorial can serve to improve any photos that especially include buildings, streets, bridges, etc...

(Subtitulos En Español: Sí)

Click Here For More Details About This Tutorial + Bigger Images

JOIN NOW TO GET ACCESS TO ALL TUTORIALS!

HOW TO TURN YOUR PHOTO INTO A FLASHY POSTER AD

Photoshop Tutorials ::

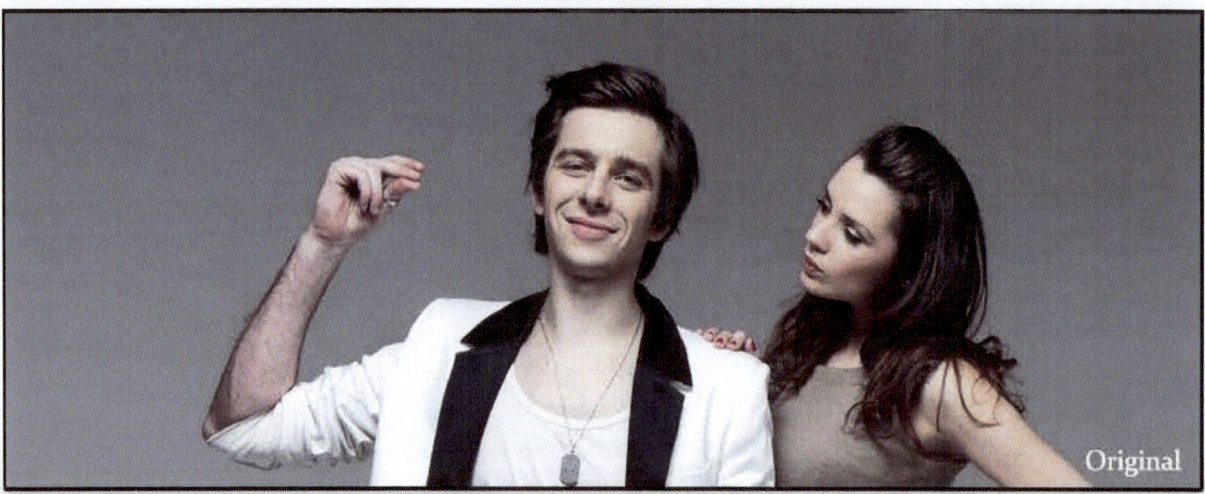

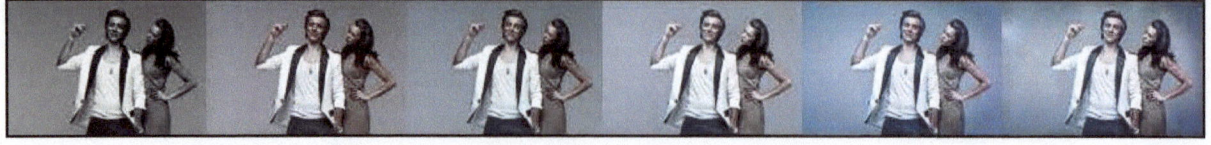

GIVING YOUR PHOTOS A SLICKER, EYE CATCHING & MORE COLORFUL LOOK

Photoshop Tutorials ::

Retouching + Color Grading Tutorial

In this **110-minute Video Tutorial**, we will be transforming an unretouched photo of two models into a slicker and flashier image that will look like some poster ad used to promote products such as soft drinks or candies! Menthos anyone?!

While we are doing this Photoshop tutorial, we will mostly concentrate on changing the look of the skin, add colored lights from both sides reflecting on the models' skin, add a much more interesting background and of course, we will spend some time color correcting/grading our image

If you want to add some 'flash' to your photos, then this tutorial is for you!

(Subtitulos En Español: Sí)

CLICK HERE For More Details About This Tutorial

HOW TO RETOUCH YOUR PORTRAITS LIKE THE PROS

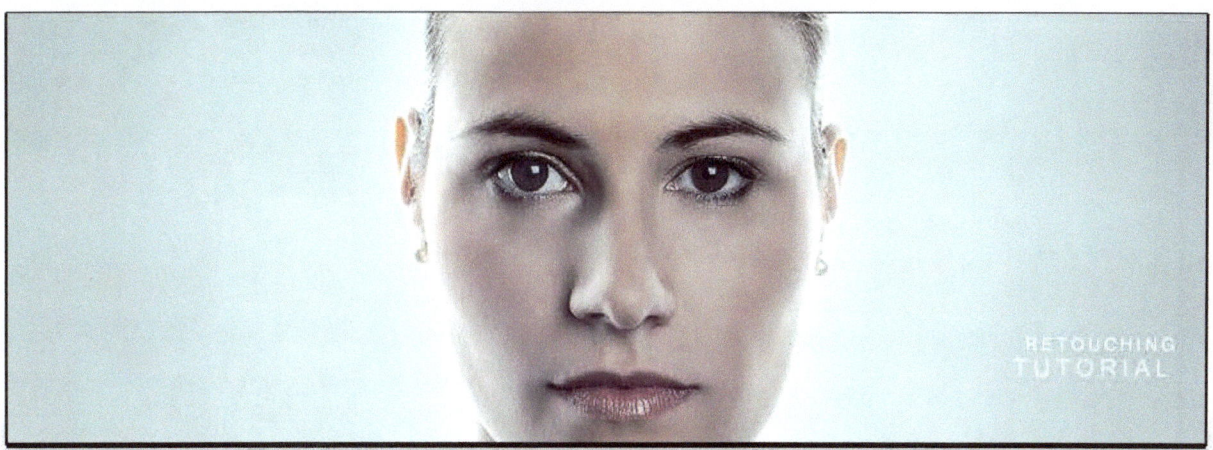

Photoshop Tutorials ::

GIVING YOUR SUBJECTS THE FLAWLESS LOOK THEY ALWAYS WANTED

Retouching Tutorial

Retouching is something photographers always end up doing when taking portraits but one particular popular look, one that we often see in magazines or ads for beauty products is the flawless "airbrushed" look. Well, there's no airbrushing going on in this **Photoshop tutorial** but what we will do here is take the unedited photo of a model with minimal make up and we will "glam it up", get rid of all imperfection and finally create the type of photo we can often see in beauty product ads and fashion magazines. Click the link below to learn more.

Update For this retouching tutorial, I am using a completely different technique than the one I used for the NEW retouching tutorial at the top of this page. Both techniques are really useful and can be used for different situations.

(Subtitulos En Español: Aún No)

Click Here For More Details About This Tutorial + Bigger Images

HOW TO GIVE A PHOTO A COOL GRUNGY DESATURATED LOOK

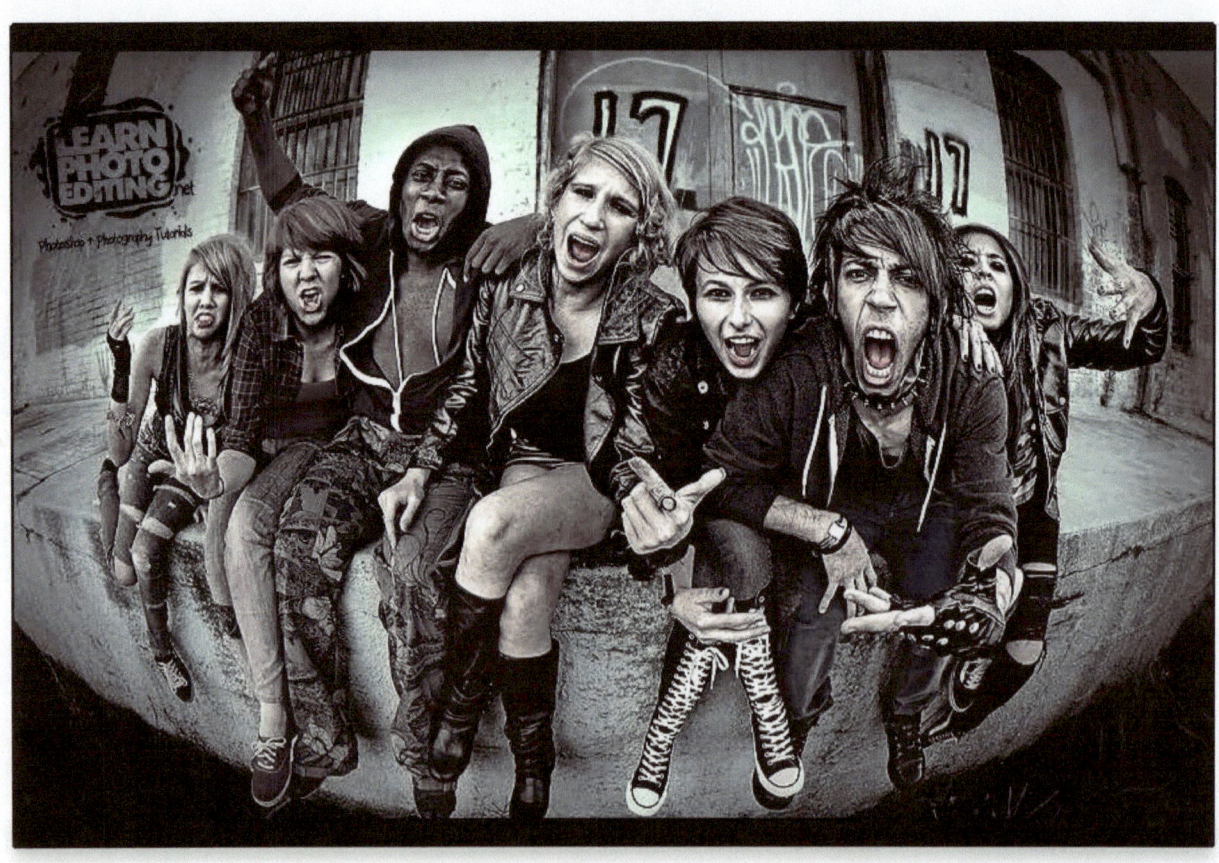

Photoshop Tutorials ::

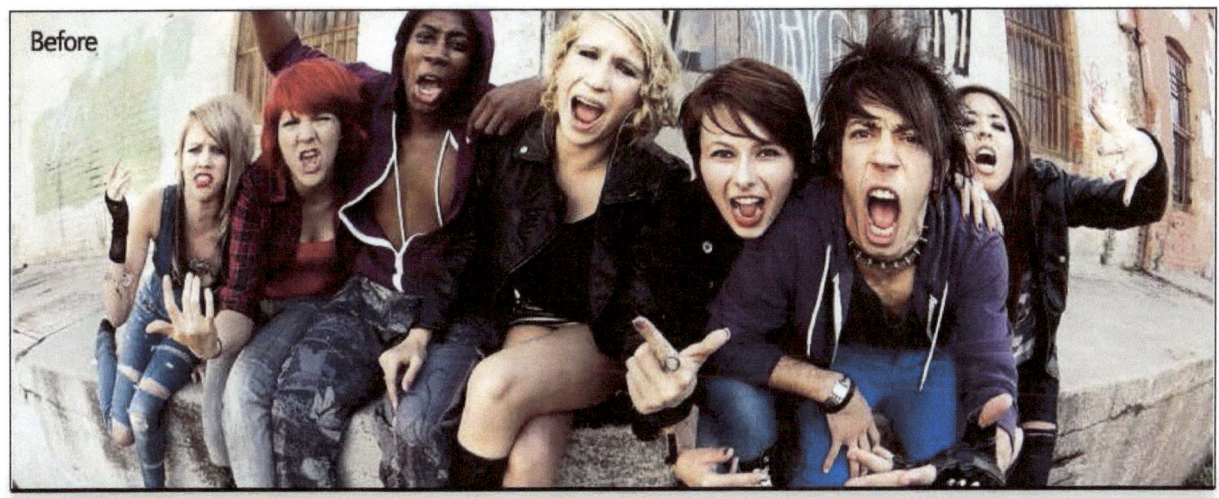

TURNING A PHOTO INTO AN EDGY COVER ART

Photo Editing Tutorial

In this **85-minute Video Tutorial**, we will transform this photo of "rebellious" teenagers into something much edgier and grungier, something that could certainly be used as a poster or album cover for a music band. This look/effect could also be used for photos of extreme sports or even protraits!

In this tutorial, we will explore different editing techniques that will allow us to bring out the details in our image, improve contrast and adjust the colors to give us the look you see above.

(Subtitulos En Español: Sí)

Click Here For More Details About This Tutorial + Bigger Images

JOIN NOW TO GET ACCESS TO ALL TUTORIALS!

HOW TO DO AN EXTREME MAKEOVER DIGITALLY IN PHOTOSHOP

Photoshop Tutorials ::

TRANSFORMING A MODEL INTO A SUPERMODEL

Advanced Retouching + Color Grading Tutorial

In this **MASSIVE 2 hour VIDEO tutorial**, we will digitally transform a model into a Supermodel using advanced retouching techniques. This is a tutorial I'm doing in collaboration with popular professional photographer **Bishop Bautista** (www.bishopbautista.com) who took the original photo. This tutorial was actually inspired by the way he edited and transformed that same exact photo. I tried to somewhat recreate what he did and this is my version and I'll show you exactly, step by step, how I did it!

I believe that anyone with basic skills in Photoshop can do this tutorial and once you'll master this extreme transformation technique, you'll be able to not only do wild transformations like this one but also more subtle ones that your subject will certainly appreciate and be amazed by!

Photoshop Tutorials ::

(Subtitulos En Español: Aún No)

Click Here For More Details About This Tutorial + Bigger Images

HOW TO BRING OUT COLORS & DETAILS IN YOUR PHOTOS

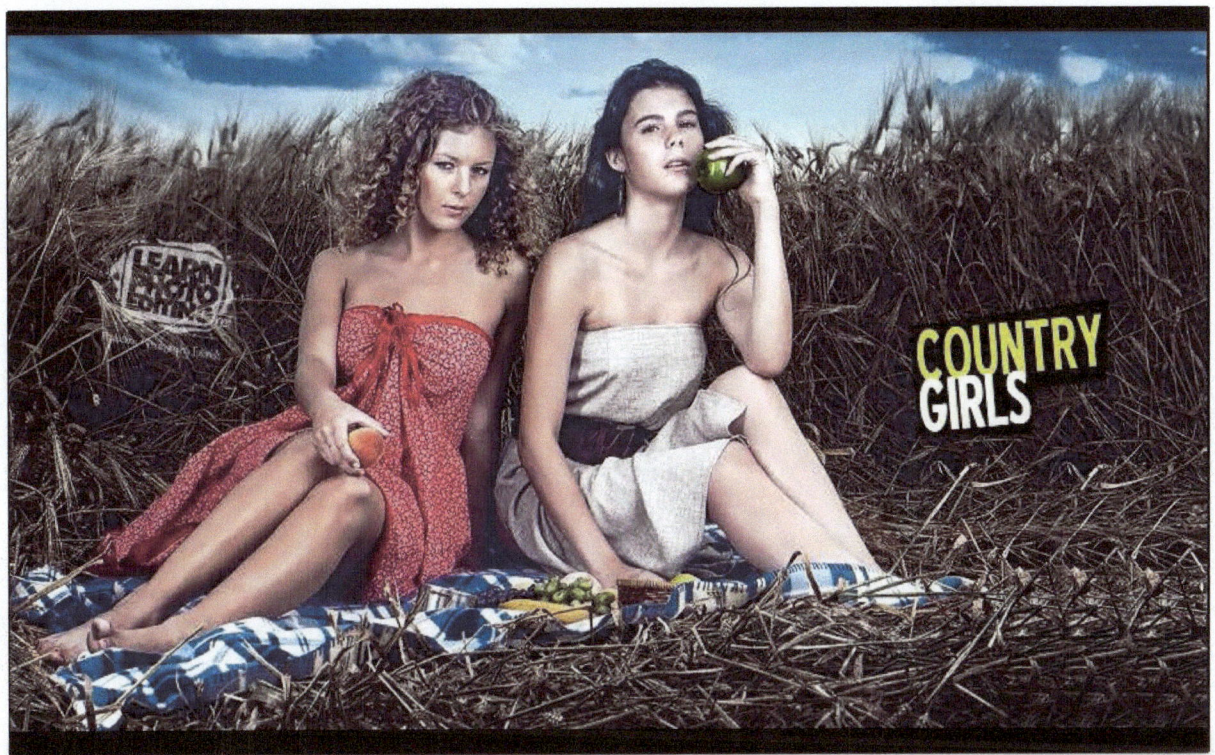

Photoshop Tutorials ::

TURN A PHOTO INTO A "REALITY SHOW" POSTER AD

Advanced Color Grading Tutorial

In this **52-minute video tutorial** we will use advanced color grading techniques to create a **tone mapping effect** without the use of any plugins or 3rd party software, we'll only be using Photoshop and what comes with it. We will start out with a photo taken with the aid of an off-the-camera flash and turn it into some sort of "reality show" poster ad. Taking a photo while using an additional fill-light or reflectors helps us retain a lot of details in the shadows and highlights which make it easier in post-production to really push the color grading.

This tutorial will be really helpful to anyone who wants to give their photos a professional look with richer colors and higher contrasts. Click the link below to learn more.

(Subtitulos En Español: Aún No)

Click Here For More Details About This Tutorial + Bigger Images

JOIN NOW TO GET ACCESS TO ALL TUTORIALS!

HOW TO CHANGE THE LOOK OF A DULL PHOTO WITH COLOR GRADING

Photoshop Tutorials ::

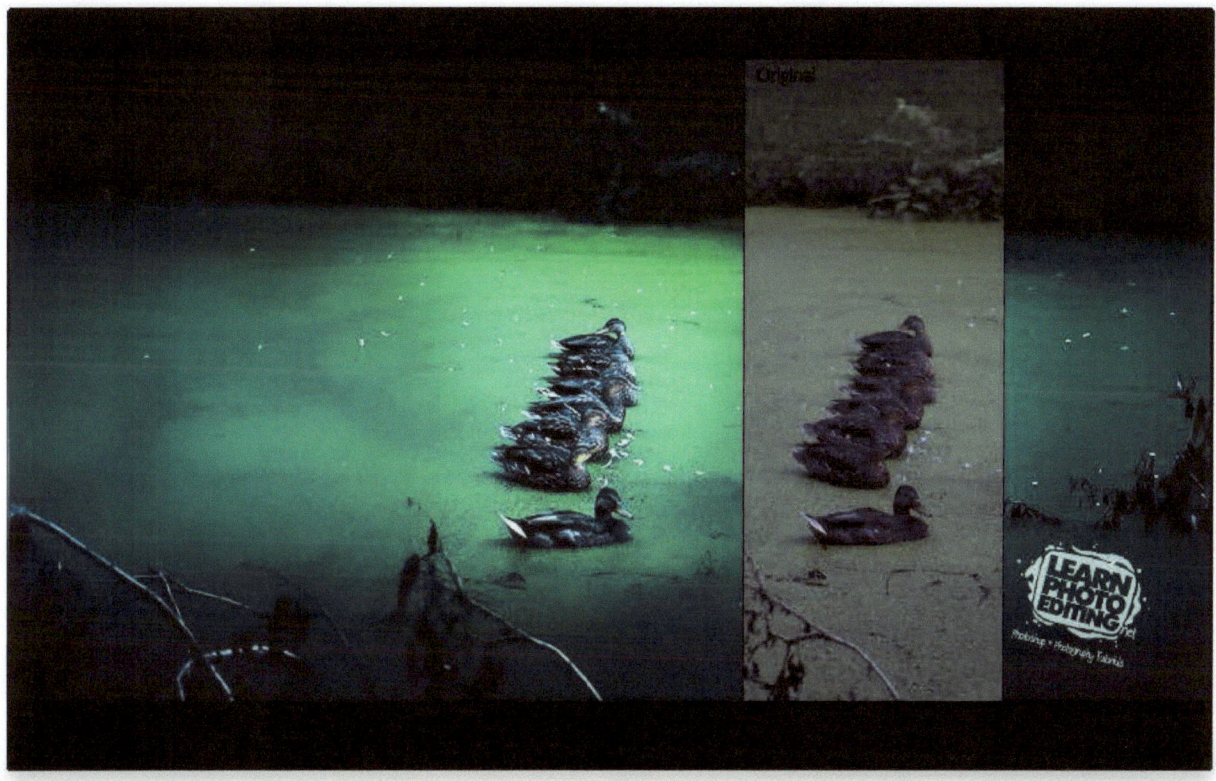

PUSHING A RAW PHOTO TO THE MAX IN PHOTOSHOP

Color Grading Tutorial

In this **57-Minute Video Tutorial** I take a RAW photo and transform it into something much more interesting by pushing the color grading to the max. I start off in the Photoshop RAW photo editor (Camera Raw) and go through my usual workflow to prepare the photo for an extreme transformation in Photoshop. Then I show you all the steps I took and techniques I used to achieve the image you see right above!

Shooting RAW is so essential in my opinion to really get the most out of your photos, to be able to bring back the details in the shadows and highlights but also to be able to bring back colors that could have been lost if you shot JPEGs.

(Subtitulos En Español: Aún No)

Click Here For More Details About This Tutorial + Bigger Images

HOW TO MAKE THE MOST OUT OF YOUR RAW PHOTOS

Photoshop Tutorials ::

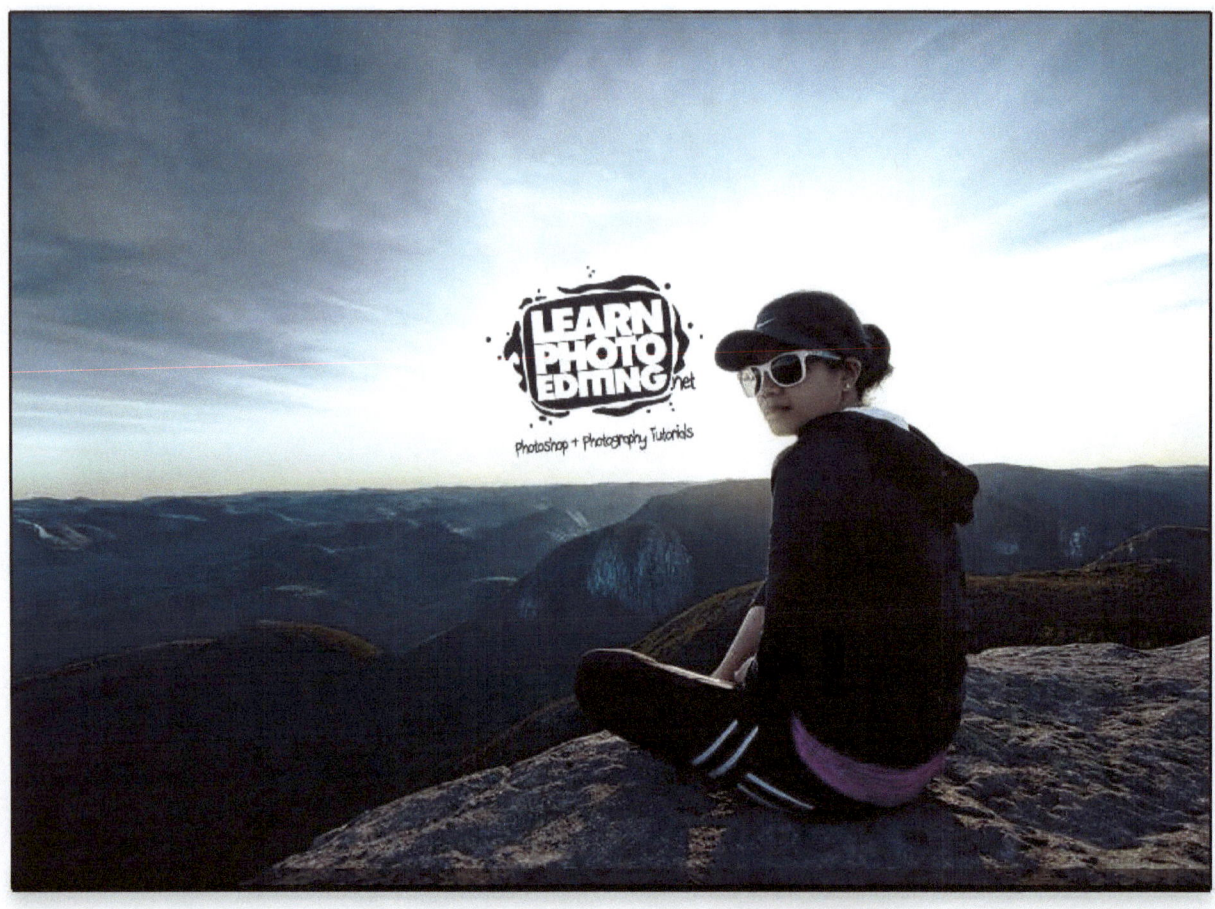

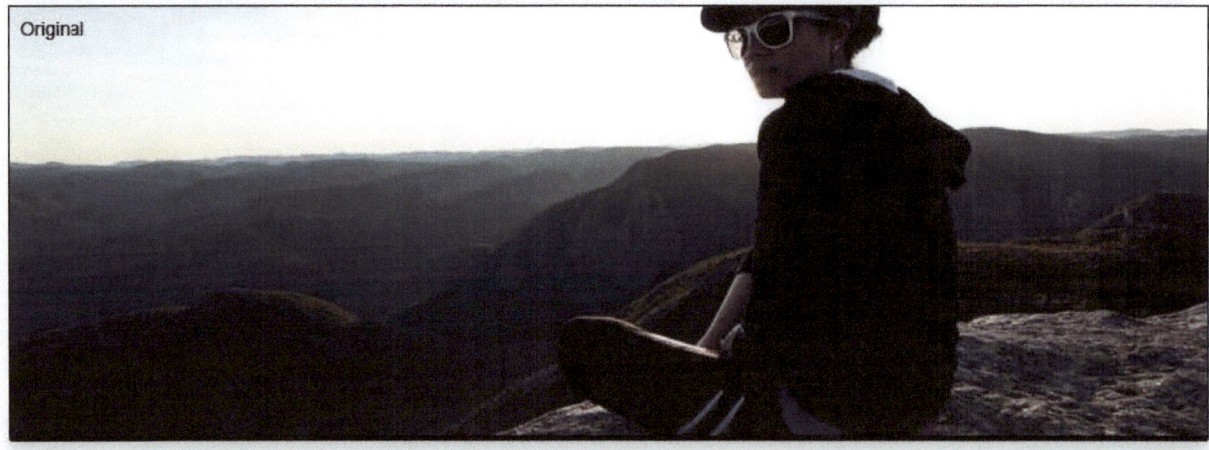

TURN A PHOTO WITH STRONG SHADOWS & HIGHLIGHTS INTO SOMETHING THAT LOOKS LIKE A HDR PHOTO

Advanced Color Grading Tutorial

In this **45-minute video tutorial** I will show you how you can get the most out of a RAW photo especially

Photoshop Tutorials ::

when your subject or the sky couldn't be properly exposed. When you take photos in nature and you don't have with you a reflector, especially when the sun is going down and you want to capture it along with your subject, you'll run into some problems. Either the sky will be blown out or your subject will be too dark. You can however with Photoshop correct that problem, bring out hidden details in the shadows and highlights as well as colors you didn't think were there. If you want to make your photos "pop" more, this is the tutorial for you!

(Subtitulos En Español: Aún No)

Click Here For More Details About This Tutorial + Bigger Images

HOW TO CREATE A LIGHTBOX FOR POCKET CHANGE!

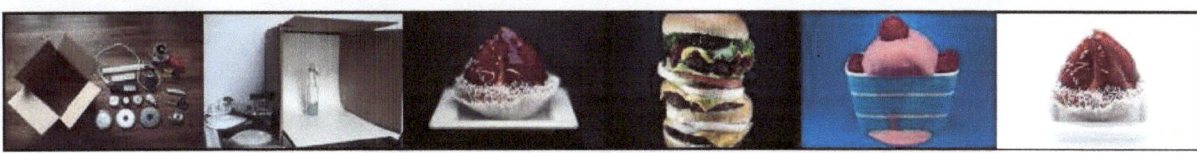

CREATING A SUPER CHEAP LIGHTING SETUP FOR OBJECT PHOTOGRAPHY

Lighting + Color Correcting/Grading Tutorials

Photoshop Tutorials ::

This one is a huge tutorial, actually 11 wrapped up into one. 11 objects were photographed using different lighting setups and I will demonstrate in details how each were done on video. Then I go through how I color corrected/graded in Photoshop each of the 11 photos.

The entire goal of this tutorial was to build the cheapest lightbox possible that would also give you professional results for photos of products you are selling, photos of food for your blog, stock photography, photos for your design business, etc… All the lights used were bought at the dollar store and at my local hardware store for barely any money. Click the link below to learn more.

(Subtitulos En Español: Aún No)

<u>Click Here For More Details About This Tutorial + Bigger Images</u>

DIGITAL PAINTING FOR BEGINNERS: HOW TO PAINT WITH A MOUSE

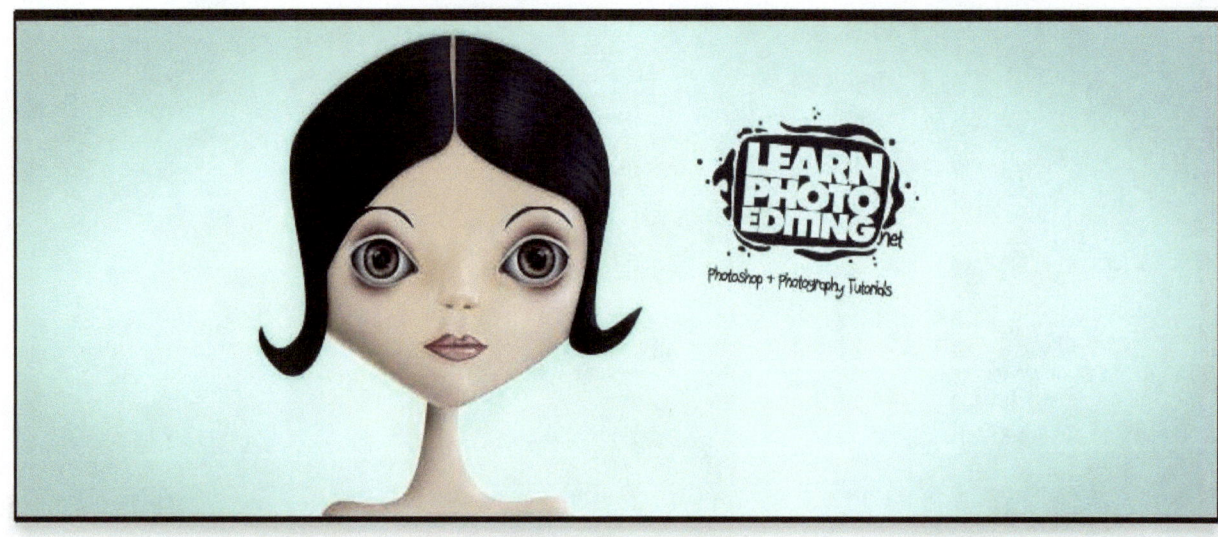

NO GRAPHIC TABLET NEEDED, PAINT A GIRL FROM SCRATCH WITH YOUR MOUSE

Digital Painting Tutorial

In this **3-hour video tutorial** I'll show you how you can take retouching to the next level by mastering digital painting. In this tutorial, we will create everything from scratch, the eyeball, the iris, the eyes, the face, the nose, the mouth, the hair and the shoulder/neck.

Photoshop Tutorials ::

Digital painting can really be difficult, it usually requires a digital tablet and if you are not a great painter to begin with, you are looking at a steep learning curve. In this tutorial, I show you techniques any beginnners in digital painting can recreate and that, with his/her mouse!

Once you master those techniques, you'll be able, for example, to add digitally painted eyes, like on the 'asylum lady' image above, which will give your images a really cool and original look!

(Subtitulos En Español: Sí)

Click Here For More Details About This Tutorial + Bigger Images

HOW TO CREATE FANTASY CHARACTERS IN PHOTOSHOP

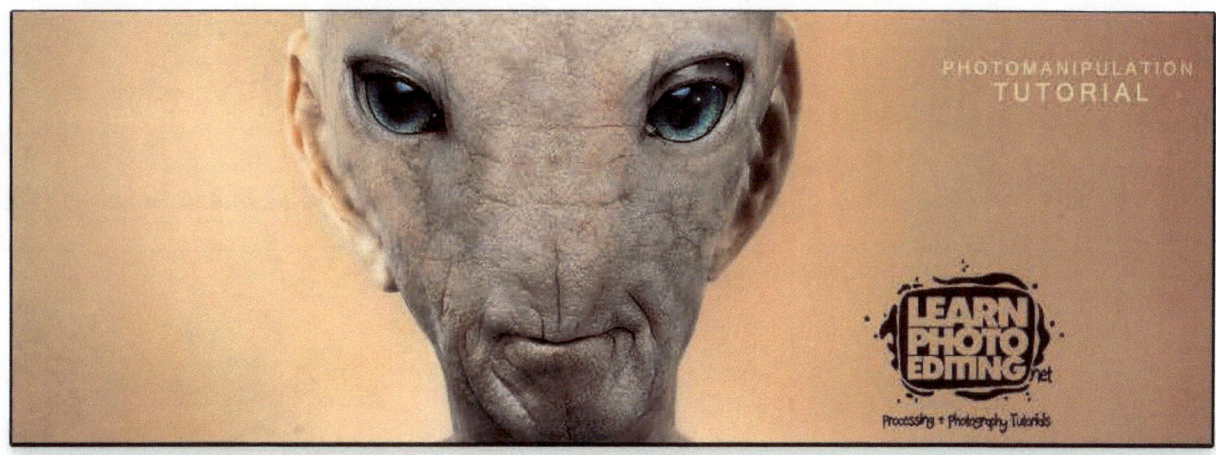

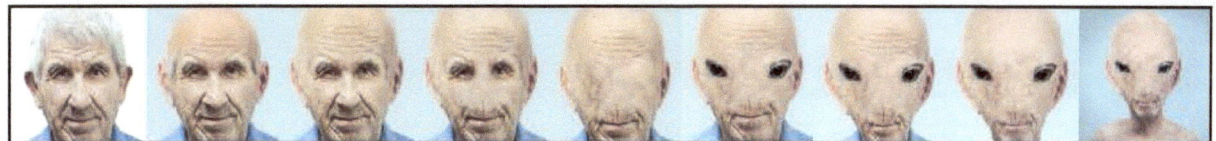

TRANSFORMING AN OLD MAN INTO AN ALIEN WITH PHOTO MANIPULATION

Photomanipulation + Color Grading Tutorial

What you can do with photomanipulation is only limited by your imagination. No need for any 3D softwares to create what you have in mind, all you need is **Photoshop**. In this tutorial, I will show you step-by-step how I turned an old man into an alien creature. With the knowledge you'll acquire here, you'll be able to do much more than just aliens, you will be able create your own photomanipulations and transform any image you want that you can use for any purpose you want. Aside from being a fun thing to do, photo manipulations are especially usefull for creating ads or high impact images for your blog. Click the link below to learn more

(Traducción En Español: Aún No)

Click Here For More Details About This Tutorial + Bigger Images

Photoshop Tutorials ::

JOIN NOW TO GET ACCESS TO ALL TUTORIALS!

HOW TO MAKE A PORTRAIT POP OUT OF THE SCREEN

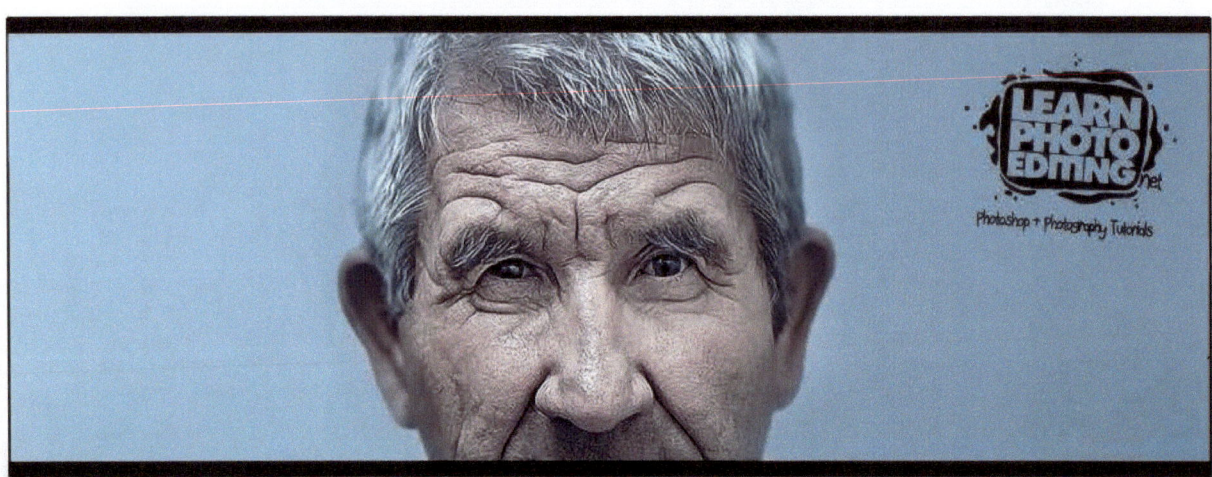

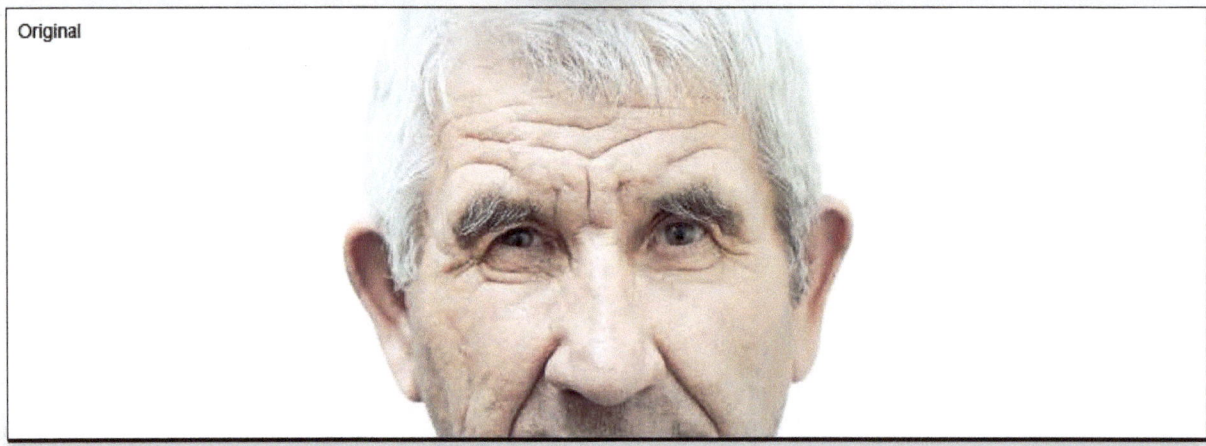

USING ADAVANCED PROCESSING + COLOR GRADING TECHNIQUES TO INCREASE THE DETAILS OF THE FACE

Color Greading Tutorial

Make your subjects "pop" by increasing the details and realism of your photos. This **Photoshop tutorial** will focus on just that where we will start with a generic photo of an old man and then using different techniques we will transform the photo into something much more eye-catching. Click the link below to learn more.

(Traducción En Español: Aún No)

Click Here For More Details About This Tutorial + Bigger Images

HOW TO TRANSFORM YOUR PORTRAITS WITH COLOR GRADING

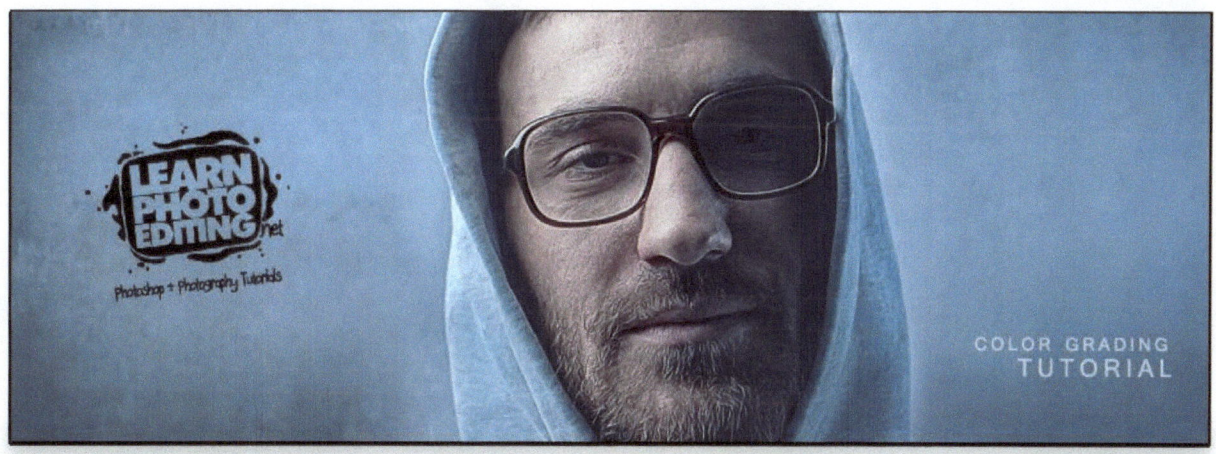

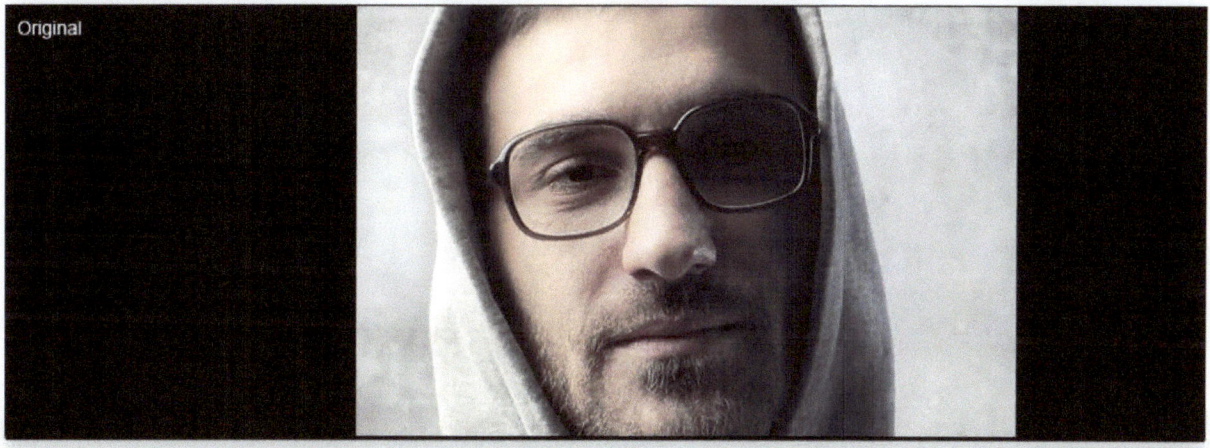

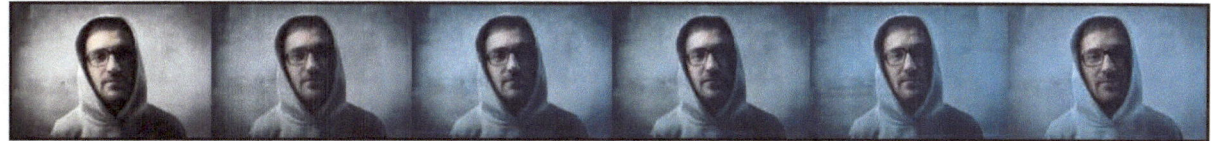

PUSHING THE COLORS AND REDUCING THE SHADOWS

Color Grading Tutorial

In this tutorial, we will push the limits of color grading without degrading the image. We will add colors to a very grayish, nearly black and white photo and then we will bring back the details from the shadows resulting in a drastically changed and more pleasing look. Click the link below to learn more.

(Traducción En Español: Aún No)

Click Here For More Details About This Tutorial + Bigger Images

HOW TO CREATE A ZOMBIE INFESTED CITY

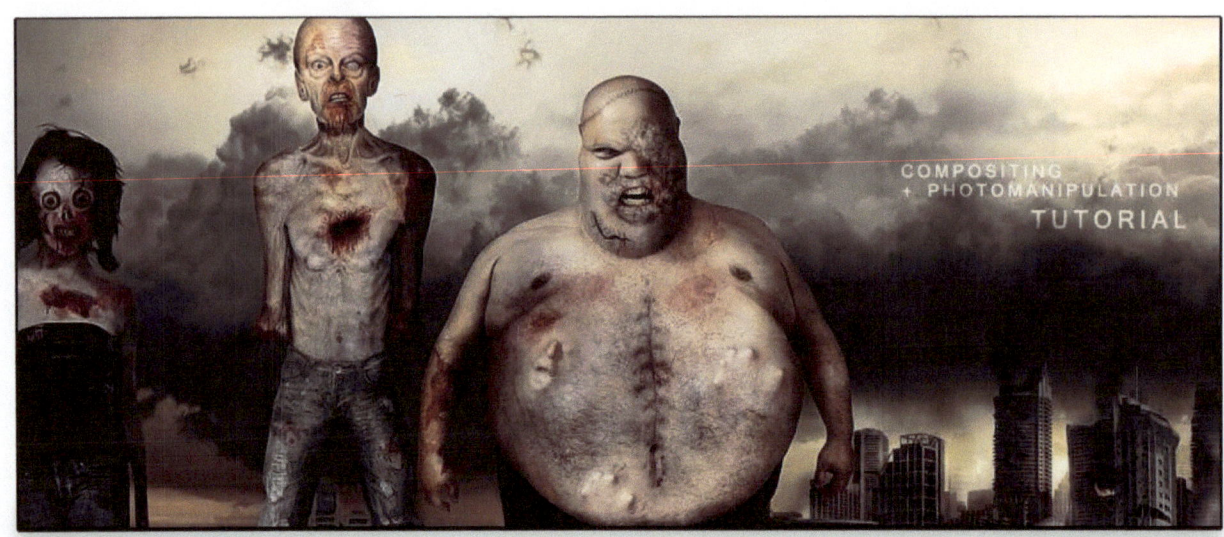

COMBINING PHOTOMANIPULATION & COMPOSITING TO CREATE A POST-APOCALYPTIC SCENE

Photo Manipulation + Compositing Tutorial

Compositing is a very useful procedure that consist of combining visual elements from separate sources into a single image - it is a process used for many purposes but it is especially useful for creating a fantasy background for your model/character/subject. Compositing is a tool anyone who wants to spice up their images need in their toolbox.

In this **Photoshop tutorial**, I used compositing to create a burning city with crumbling buildings that served as a backdrop for my post-apocalyptic scene and then I used photomanipulation to transform regular people into the flesh-eating zombies you see in the foreground! Click the link below to learn more.

(Traducción En Español: Aún No)

Click Here For More Details About This Tutorial + Bigger Images

HOW TO IMPROVE THE LOOK OF YOUR WEDDING PHOTOS

Photoshop Tutorials ::

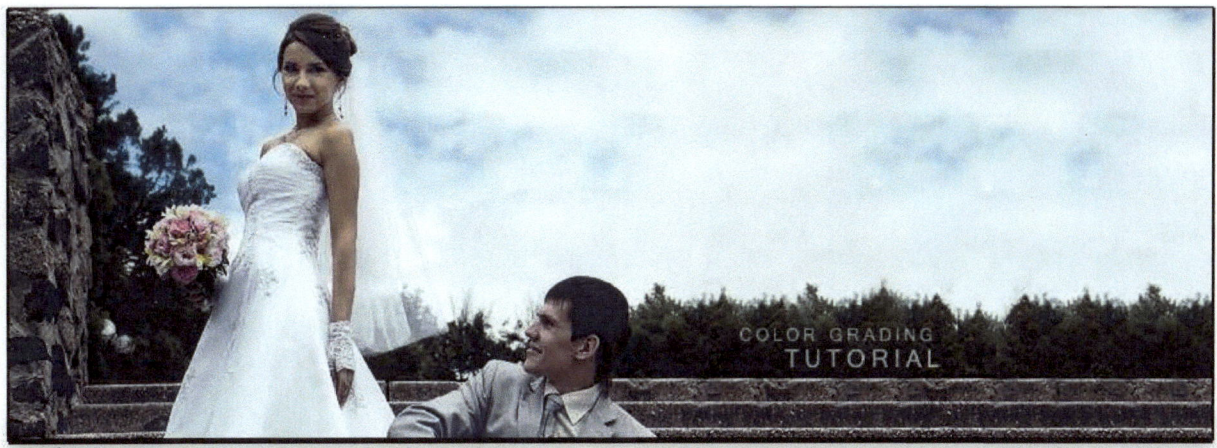

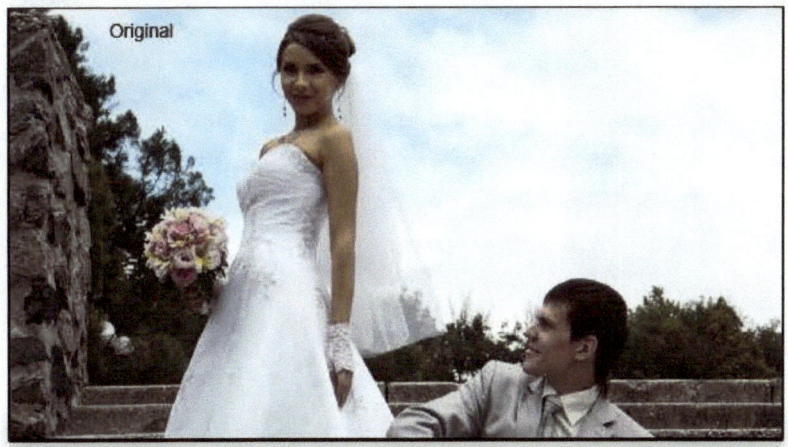

USING COLOR CORRECTING + COLOR GRADING TO ENHANCE YOUR PHOTOS

Color Grading + Color Correcting Tutorial

This is a **25 minute long video tutorial** going through the steps I take to color correct and color grade my photos. This is the perfect tutorial to learn the basics of photo editing in Photoshop and get you started. Click the link below to learn more.

(Subtitulos En Español: Si)

Click Here For More Details About This Tutorial + Bigger Images

AND THE LIST GOES ON BELOW: MORE TUTORIALS YOU'LL GET ACCESS TO BY BECOMING A MEMBER!

SCROLL DOWN TO JOIN!

TAKE YOUR SKILLS TO THE NEXT LEVEL

Hi, my name is Patrick and I'm a professional graphic artist, photo editor, colorist (photo & video) and photographer.

My main goal with this site is to teach you how you can create better photos by spending as little money as possible and it all starts with photo editing.

No, you don't need a $3000 camera or a $1500 lens to take professional quality photos. In fact, the difference you will notice between a photo taken with an entry level DSLR camera + the kit lens and the same photo taken with the Canon 5D Mark III for example is minimal compare to the difference you'll notice between one photo expertly edited in Photoshop and the same that wasn't. If you already have Photoshop, *(you can download the free trial for 30 days btw)* you can improve your photos dramatically by learning how to properly color correct and color grade.

Then, you can take your photos to an whole new level if you can master the art of what we call photomanipulation, compositing and retouching. By mastering those techniques, you will be able to turn your photos into digital art!

Some sites are selling their tutorials $25+ a piece, at only $5 per tutorial, I could perhaps charge $100 for all of them, but I want to give you a MUCH better deal than that! When you join this site, you pay a one-

www.ingramcontent.com/pod-product-compliance
Lightning Source LLC
Chambersburg PA
CBHW051111180526
45172CB00002B/864